Wisdom With
Understanding
is Better
Than Rubies

Lurine Karon Greenberg
Fine Arts Collection

impressionist CATS & DOGS

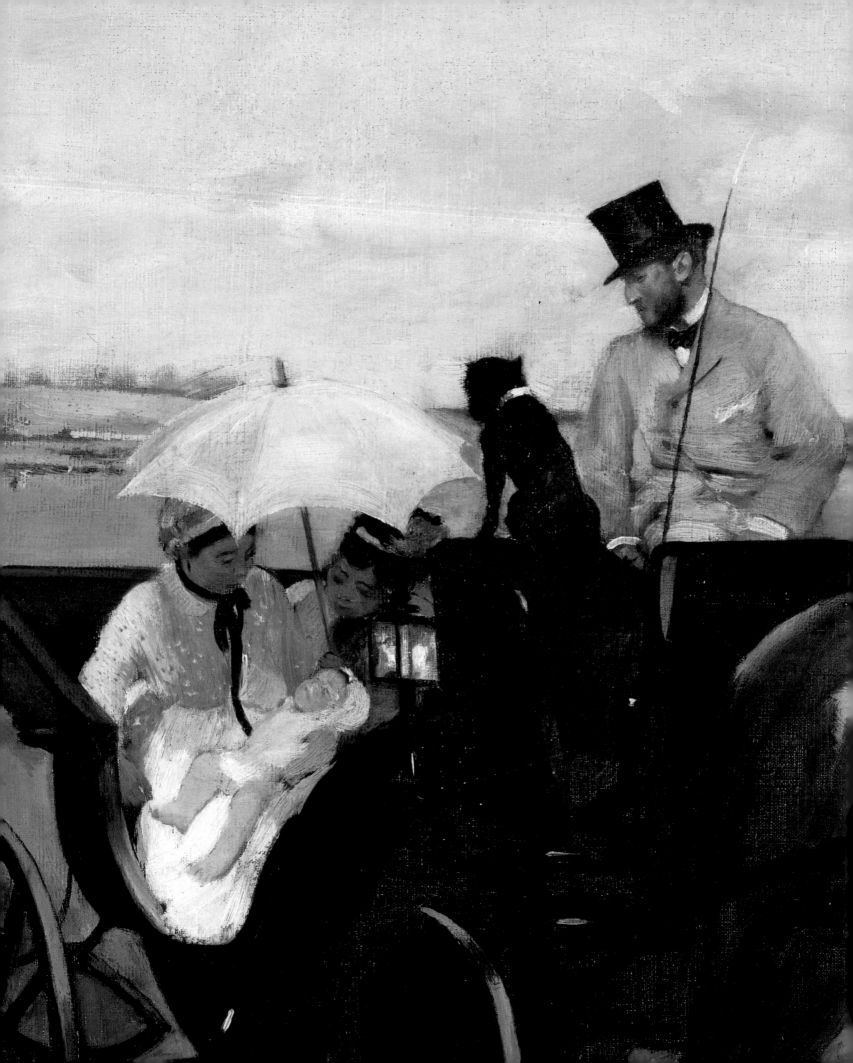

James H. Rubin

impressionist CATS & DOGS

Pets in the Painting of Modern Life

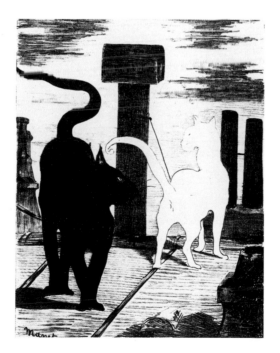

Yale University Press · *New Haven* & *London*

Designed by Gillian Malpass

Printed in Italy

Library of Congress Cataloging-in-Publication Data

Rubin, James Henry.
Impressionist cats and dogs: pets in the painting of modern life /
James H. Rubin.
p. cm.
Includes bibliographical references and index.
1. Cats in art. 2. Dogs in art. 3. Painting, French.
4. Impressionism (Art) – France. I. Title.
ND1380.R75 2003
758′.3′094409034 – dc21 2003002422

A catalogue record for this book is available from
The British Library

Page i Paul Cézanne, *A Modern Olympia* (detail), 1873, Musée d'Orsay, Paris

Frontispiece Edgar Degas, *A Carriage at the Races* (detail), 1869,
Museum of Fine Arts, Boston.

Page iii Edouard Manet, *Cats' Rendezvous*, 1868, lithograph,
New York Public Library

Facing page Anonymous, *Cats Opening an Armoire* (detail), wood engraving from
Ernest Menault, *L'Intelligence des animaux*, Paris, 1869, p. 267.

CONTENTS

facing page Pierre-Auguste Renoir, *Girl with a Cat* (detail of fig. 89).

facing page Pierre-Auguste Renoir, *Bather with Griffon* (detail of fig. 68).

"The more I know people, the more I love my dog."
– *Blaise Pascal*

"To understand a cat, one must be like a woman or a poet."
– *Champfleury*

"Rouaf! Rouaf! – Bou! Bou! Bou! – Aï! Aï! Aï! – Bou! Bou! – Rouaf! Rouaf! –
Huuuum! Huuuum! – Bou! Bou! – Rouaf! Rouaf! – Aï! Aï!"
– *Henry de Kock* [untranslated]

INTRODUCTION

Animal Images in Modern Light

*J*ust as Impressionist painting appeals to visual pleasure, cats and dogs brighten one's emotions. Put the two together and the result is pure delight. In their brilliant images of modernity and leisure, Impressionist painters often painted pets. Household animals were a part of middle-class life captured by works whose pictorial riches reveal the comfort and wellbeing of nineteenth-century prosperity. This book aims at expanding and deepening the appreciation both of pets and art by combining imagery with historical knowledge. As an art historian who adores Impressionist paintings and quotidian quadrupeds, I want to share what I have learned of the light they shed on one another. I have tried to write an engaging book, though one filled with fact. Art history, as well as pets, can be enjoyable. Animals can help one learn – not only about people but about pictures. So beyond its immediate focus, this book is also about looking at and understanding art.

One of the most noticed elements in Edouard Manet's still provocative *Olympia* (fig. 1) was the pet alley cat, standing at the foot of the naked prostitute's bed. This painting has come to embody the rebelliousness of modern art. One of the greatest of all Impressionist portraits is Pierre-Auguste Renoir's *Madame Charpentier and Her Children* (fig. 2). In it, there is a prominently featured furry guardian, a faithful Newfoundland dog named Porthos, after one of the Three Musketeers. The role of pets in the success of such paintings is the subject of this book. My examples represent two important and often coexisting sides of pet presences in Impressionism (as in all painting) – the symbolic and the natural. In *Olympia*, the cat stands for the independent artist. In *Madame Charpentier and Her Children*, the dog is a crucial member of a loving family. Thus, the book is not just about pictures of animals; nor is it a collection of favorite pet portraits. Its theme is what this most natural of elements in representations of modern life can say about both the animal's and the artist's society and times.

A question the book will answer is why the most famous Impressionist, Claude Monet, almost never painted pets, even when working side by side with

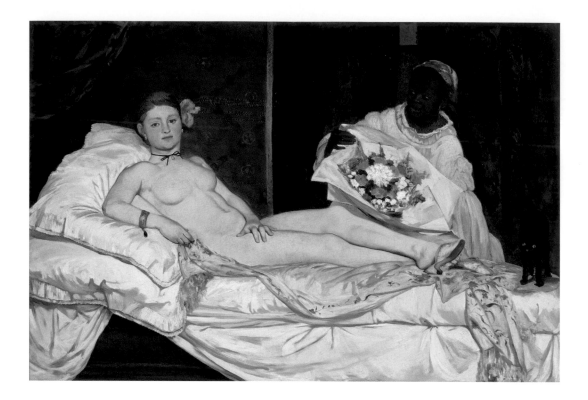

1 Edouard Manet, *Olympia*, 1862–63, Musée d'Orsay, Paris.

Renoir, who included them in the same scene. Impressionism is renowned for its commitment to the world as it appeared. Before the Impressionist revolution, artists were expected to paint subjects from history or literature or to idealize the natural landscape. Art was ruled by a powerful Academy, which strictly enforced these rigid principles. The use of symbolic figures and illustrations of stories in art were common and admired. In reaction against such constraints on artistic freedom, a new generation of artists claimed there was much to celebrate in their everyday surroundings and among their peers. They insisted on painting directly from life, often out of doors. While pets seem a small aspect of that life, they introduce both charm and meaning. Indeed, in pets the natural and the symbolic usually overlap, and animals often interact with or reflect relationships between the human figures represented with them. So it is possible to discover through pets that the Impressionists did not entirely abandon the symbolic and narrative traditions they disfavored, but recast them into natural appearances.

The book's illustrations should please both pet and art lovers. They prove that images are far more eloquent than words in embodying their time. I have

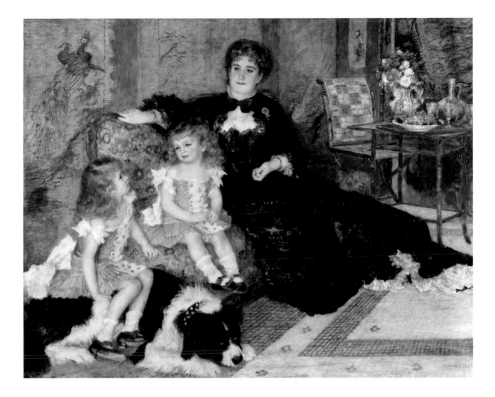

2 Pierre-Auguste Renoir, *Madame Charpentier and Her Children*, 1878,
The Metropolitan Museum of Art, Catharine Lorillard Wolfe Collection, Wolfe Fund, 1907. (07.122).

made some observations on pet ownership, illustrated by paintings, and some notes on the place of Impressionism in the long history of animal painting. I looked in early pet handbooks and treatises on animal intelligence for nineteenth-century opinions on cats and dogs as well as for illustrations to compare with Impressionist works. The book begins with a few samples of animal imagery in the earlier history of painting. It moves quickly to the mid-nineteenth century and the beginning of modernity. The new theories of evolution compared the beastly and the human. At the same time, pet ownership had so expanded that it came under the authority of the tax collector and the law. An inescapable aspect of everyday life, pets thus often appear in the Impressionist vision of the world. Even when artists used animals for symbolic possibilities, their choices were related to this popularity. One of the most important things I learned is how pets in art reveal artists' attitudes not just toward animals, but toward the people they painted – including themselves in their identities as artists.

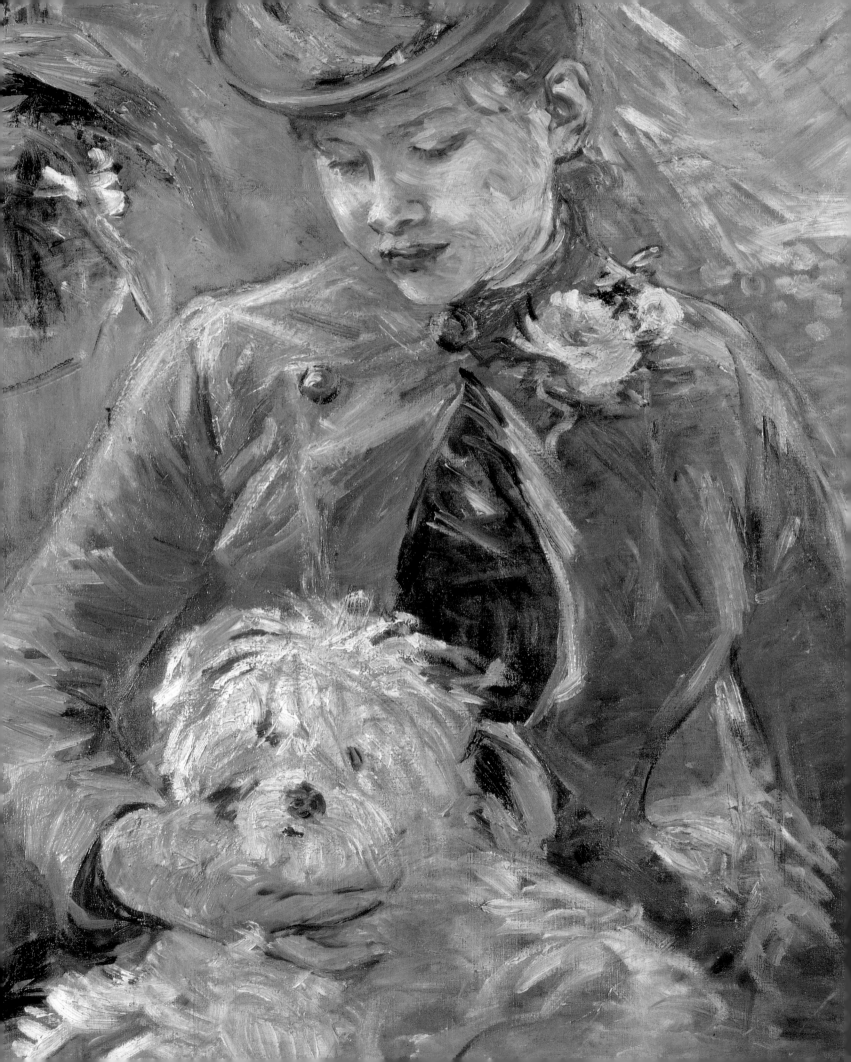

Beasts Compared with Man

\mathcal{A}nimals have always been close to the heart of humankind. They appear in the earliest imagery as the very first subjects of art. In the prehistoric caves at Lascaux in France and Altamira in Spain, paintings of wild bison, horses, deer, and cattle reflect human dependence on nature for sustenance, both physical and spiritual.[1] In the hunting scenes of ancient Mesopotamia, Assyrian kings prove their courage by killing lions from their chariot.[2] In all times and places, relations between man and beast are expressions of power and status. Egyptian gods were represented as animals or combinations of animal and human form. The hieroglyphic symbol for a god was the falcon, a powerful bird which flew at great heights, near to the sun, giver of all life.[3] Animals represented *otherness* – difference from humanity. Early civilizations must have envied the powers they saw in beasts – the flight of birds, the sense of smell in dogs (which have forty times as many olfactory nerves as humans), the fabled "nine lives" of cats, and simply the ability to survive in the wild. Through comparisons of themselves with animals, in other words, our ancestors recognized the limits of being human. So in sanctifying animals, they hoped to harness and appease the mysterious forces that created them.

Egyptian art was the first to include domesticated species – especially cats. The cat goddess Bastet was a guardian as well as the patroness of pleasure and music.[4] Indeed, the cat's associations with sex and art stem from the oldest roots. In the nineteenth century, Champfleury (the pen name of Jules Husson) reported that ancient Egyptian women condemned to death for adultery were cast into the river Nile in a sack containing a cat.[5] Ancient historians believed that Egyptians actually worshiped animals, since the penalties for killing most varieties were severe. It was said that if an Egyptian's house caught fire, he would save his cats first. Monkeys were so revered that, according to legend, they were served exquisite meals washed down with the finest wines. The Egyptians even mummified their pets in order to have companions in their fabulous tombs. Near places called Beni Hasan and Tuna el-Gebel, there were entire cemeteries for cats.[6]

facing page Berthe Morisot, *Young Woman with a Dog* (detail of fig. 81).

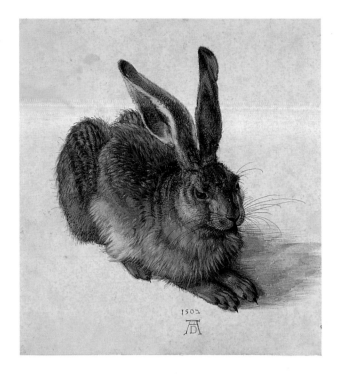

3 Albrecht Dürer, *The Hare*, 1502, watercolor and gouache, Albertina Print Collection, Vienna.

Only later in history, as humans gained self-confidence, could they believe in a God who made man in his image – God as a perfect version of the human. No longer embodying the divine, animals became companions subordinate to humans both during and after life. Medieval noblemen had canine "best friends" sculpted at the foot of their tombs. The Renaissance demonstrated an early scientific interest in observing animals as part of the natural world. In his extensive studies of human anatomy, Leonardo da Vinci drew many animal examples as comparisons.[7] Another artist with an almost scientific curiosity was Albrecht Dürer, who made studies of animals that combine exquisite beauty with rare accuracy.[8] Most famous is Dürer's watercolor of a hare (fig. 3). Its combination of aesthetic sensitivity and close observation is so compelling that it is still a standard by which naturalism – art based on direct observation – is measured. Unlike symbolic imagery, exemplified by funerary dogs embodying loyalty, Dürer's image presents the hare from an ordinary point of view. You can sense not the artist's awe but his affection. I feel as though the little fellow is depicted as if he were a pet.

Naturalistic representation of animals was taken the farthest in Northern Europe. Dogs were associated with the hunt, cats with the kitchen. The great French painter Jean-Baptiste Siméon Chardin got his start combining animals and still-life arrangements of inanimate objects.[9] In a pair of large early works, Chardin played off the role of sporting hound and domestic cat. In *The Hound* (fig. 4), a long-legged hunting dog guards an artfully arranged game-piece with a rifle, a hunting-horn, a partridge, and a hare. Through its protective posture, the dog implies a certain intelligence, despite its slightly awkward pose. The artist is striving for just the right but limited degree of character to attribute to what is still a lower species. In *The Ray* (fig. 5), the kitchen is a stage for meditations on life and death. Although the cat is the only living creature, it stops dead in its tracks, its hair stands up and its tail stiffens, as it encounters the

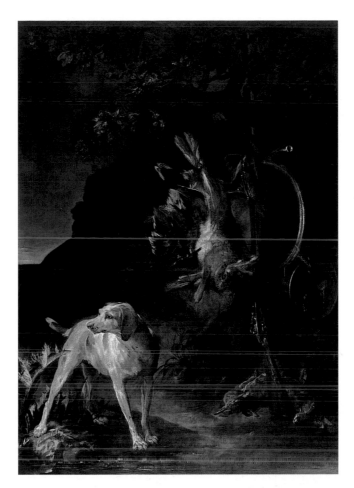

4 Jean-Baptiste Siméon Chardin, *The Hound*, c. 1725, Norton Simon Museum, Pasadena.

5 (*below*) Jean-Baptiste Siméon Chardin, *The Ray*, 1728, Musée du Louvre, Paris.

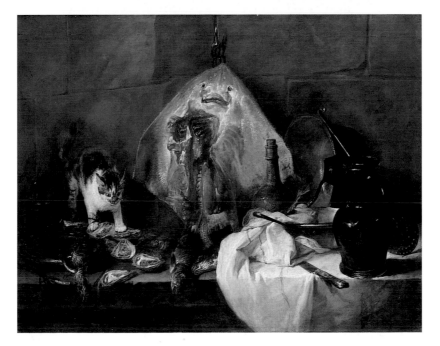

unctuous and shimmering flesh of oysters. Similarly, the viewer's attention is arrested when confronted by the ray hanging from a hook, its soft underbelly exposed with eyes gazing out and its mouth in a hapless pout. Using animal surrogates for human psychology, Chardin thus infused his work with moral possibilities.

In a more modern attitude, William Hogarth presented his dog Trump as a domestic being. In *Self-Portrait with a Pug* (fig. 6), Trump's spunky pride makes him a stand-in – an *alter ego* – for the artist. Hogarth was an engraver and painter who, against academic and aristocratic pretense, urged artists to show ordinary life.[10] Hogarth put himself in a painting within his painting, while including his favorite books and the plain tools of his ostensily simple craft. A common little beast compared with thoroughbred hunting dogs, the pet stands sturdily beside his master's work. There is an amusing role reversal here: the pug is more "real" than the painter. Who is the master? On one level, the painting displays the artist's ability to produce illusions, visual and psychological. But it also shows Hogarth's treatment of his dog as a personality, his projection of human character on to him and democratic sympathy with him. Trump embodies the humanization of household pets in modern times.

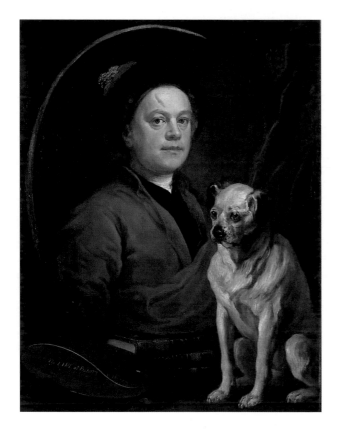

6 William Hogarth, *Self-Portrait with a Pug*, 1745, Tate Britain, London.

The key to virtually all animal imagery in art is the relationship between nature and man. In the classical world, man was believed to be "the measure of all things" – superior to nature, which God made for man's use. In the modern world, humanity became a part of nature, more equal to its other aspects, with Charles Darwin claiming links between man and beast that were unthinkable in the Bible. Yet such scientific comparisons had historical roots. Juxtapositions of human and animal faces were drawn by Leonardo da Vinci and adopted for teaching facial expression by the French academic painter Charles Le Brun (fig. 7).[11] By the

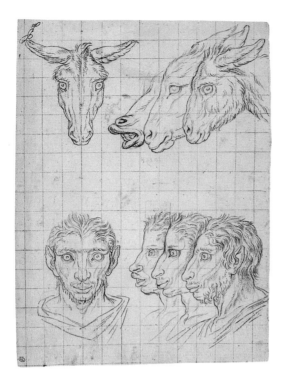

Fig. 3. — *Cynopithecus niger au repos.* F.g. 4. — Le même, exprimant sa satisfaction.

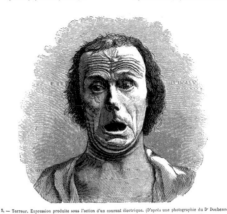

5. — Terreur. Expression produite sous l'action d'un courant électrique. (D'après une photographie du Dr Duchenne.)

7 Charles Le Brun, Two heads of asses and
four physiognomic heads inspired by the ass,
c. 1671, black ink over black chalk sketch,
Cabinet des Dessins, Musée du Louvre, Paris,
inv. nos. 28052 and 28053.

8 Illustration for a review of
Charles Darwin, *The Expression of the
Emotions in Man and Animals*, engraving,
from *La Nature*, July 4, 1874, p. 75.

late eighteenth century, the science of "phrenology" – the study of faces and
skull formations – was used to analyze character. The more a person's physiog-
nomy resembled an animal's, the less morally and intellectually developed – the
less human – he was thought to be. Charles Darwin's study of 1872, *The Expres-
sion of the Emotions in Man and Animals* (fig. 8), built on such ideas.[12] In a well-
known caricature, J.-J. Grandville expressed mid-nineteenth-century prejudices
through a progression of human to animal faces (fig. 9). In chapter 3, I show
how Edgar Degas's paintings echoed them.

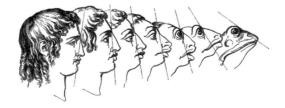

9 J.-J. Grandville, *Heads of Men and
Animals Compared*, wood engraving
from *Magasin pittoresque*, 1844.

The use of animals as measures of morality was an old tradition. Readers of Georges Buffon's influential *Histoire Naturelle* (1749–88) took for granted the French naturalist's combination of moral and physical descriptions. For example, while cats were considered sexually promiscuous and of little use except for chasing mice, dogs became faithful members of the households in which they lived, their character reflecting their environment.[13] Thus commendable, dogs were overwhelmingly the preferred companions of upper-class masters until later in the nineteenth century. Cats acquired cachet only when their independent nature made them symbols of freedom and unconventionality. It was these aspects which the avant-garde artists and writers would find attractive.

A tax on dogs was established in 1855. The city of Paris distinguished between "utilitarian" and "luxury" dogs – a difference often hard to discern.[14] But that household pets were becoming signs of social status does help to explain the rise of pet-keeping in the modern age. The exploding dog population, estimated at 100,000 in Paris during the 1840s (and which has now doubled), also attracted the police; by contrast, Manhattan now has only 23,636 dogs.[15] Along with licensing requirements came stringent steps to deal with strays, which were sent for extermination or medical experiments if not claimed from the pound within a week.[16] In French, the dog pound was called *la fourrière,* derived from the word for fur. The word is now also used for the place where police tow illegally parked cars.

A related phenomenon was the animal protection movement.[17] Following the British example, the first French law on prevention of cruelty to animals was passed in 1850. It was aimed at public morality, based on the belief that animals, as fellow beings, had some form of rights. There was also concern for public health, for there was a rampant fear of rabies. The anti-vivisection movement was an extreme version of animal protection. As science probed the mysteries of life and medicine sought to cure human ailments, animal research spread. The proximity between man and beast claimed by evolution justified the use of animals as scientific subjects. However, pet ownership and the humanization of animals could lead to an opposite position. The public became indignant, as the painful yelps of dogs and whimpering of monkeys echoed down the narrow Paris streets from the laboratories of the famous researcher Dr. Claude Bernard.

At the other extreme, for pampered dogs there were at least two bathing places in central Paris. The pet cemetery, too, was popularized during the nineteenth century. This "bourgeois status" of pets was a perennial topic for humorous lithographs by Honoré Daumier, an artist sensitive to contemporary

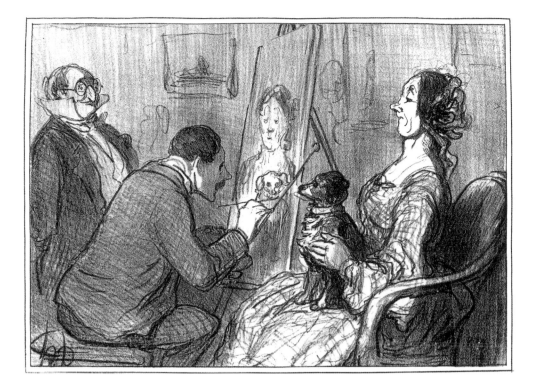

10 Honoré Daumier, *Puisque maintenant il est de la famille, il faut aussi qu'il ait son portrait,*
lithograph, 1856 (Loys Delteil, *Le Peintre-Graveur illustré (xix et xx siècles)*, Paris, 1906–30,
Daumier, no. 2940).

ways.[18] In each of his series of twelve plates entitled *La Journée du célibataire* (1839), Monsieur Coquelet (Mr. Little Rooster) is accompanied by his dog, Azor.[19] In the first plate, Azor and the cat Minette compete for their keeper's first kiss of the day. In another, they share his breakfast – Minette on his shoulder, Azor on the table nibbling from master's plate. Azor is Coquelet's companion when he leaves the house for walks in Paris (fig. 36), until they return home to Minette at the end of the day. Better known are Daumier's lithographs of 1856 about the dog tax. The first shows an exodus from France of canine refugees unable to pay. Another shows a couple telling their terrier: "There, now you've become a citizen, you pay taxes [. . .]. Our names are on your collar, so you're a member of the family. [. . .] I hope you'll conduct yourself accordingly." A third (fig. 10) shows a painter making doggie's portrait seated on mistress's lap. Its caption reads: "Now that he's a member of the family, he has to have his portrait, too."[20]

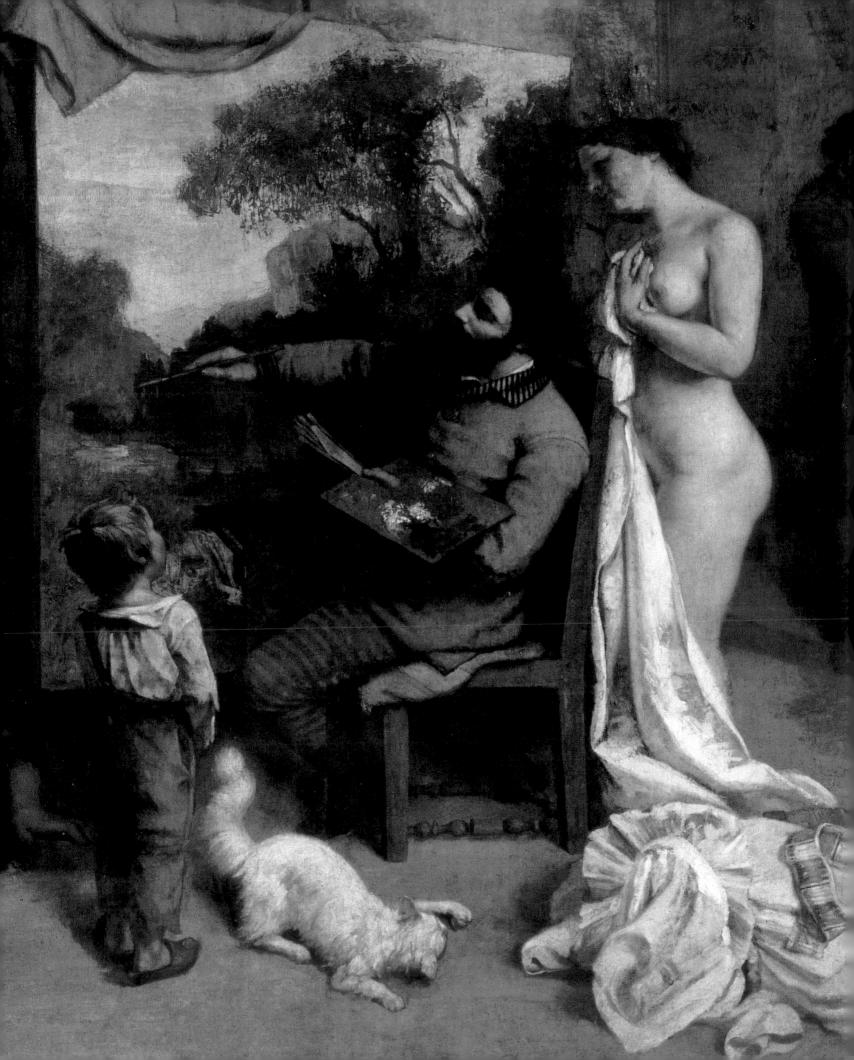

The Artist's Special Companions

The theme of this chapter is how cats and dogs were used by avant-garde painters from the 1850s onward to express the novelty of their art. Sometimes animal companions were directly symbolic characters. Sometimes their presence is a more natural one, revealing important information about the artists' lives. I begin with the cat, which has a prominent role in two of the most important paintings for the development of modern art – Gustave Courbet's *Studio of the Painter* and Edouard Manet's *Olympia*. In the nineteenth century, the two main characteristics of the un-touted tabby were said to be independence and promiscuity. They explain why Courbet and Manet used them in their artistic challenges to tradition.

The Avant-Garde Animal

The white Angora at the center foreground of Courbet's *Studio of the Painter* (fig. 11) was almost entirely overlooked until 1983.[1] Even expert art observers assumed it was a domestic presence, like other everyday aspects of Courbet's studio. But the subtitle of this large and ambitious work, *A Real Allegory Determining Seven Years of the Artist's Life*, implied that all elements in the painting – especially one as visible as this cat – had more than just descriptive value. The word "allegory" has the idea of symbolism as a central part of its meaning. Since all previous interpretations of Courbet's "real allegory" gave a role to almost every detail, why not investigate the meaning of the cat, as well? Everyone agrees that *The Studio of the Painter* expresses Courbet's claims to artistic independence. He announced as much in his Realist Manifesto – a document which accompanied the painting when he showed it.[2] So how do fluffy felines underfoot fit in? The cat symbolizes the artist's independence.

The cat's central position, its conspicuous playfulness – it has a small object in its left forepaw – and its light color, with the darker background contrasting, call out for attention. Painted cats in previous art almost always depict the more

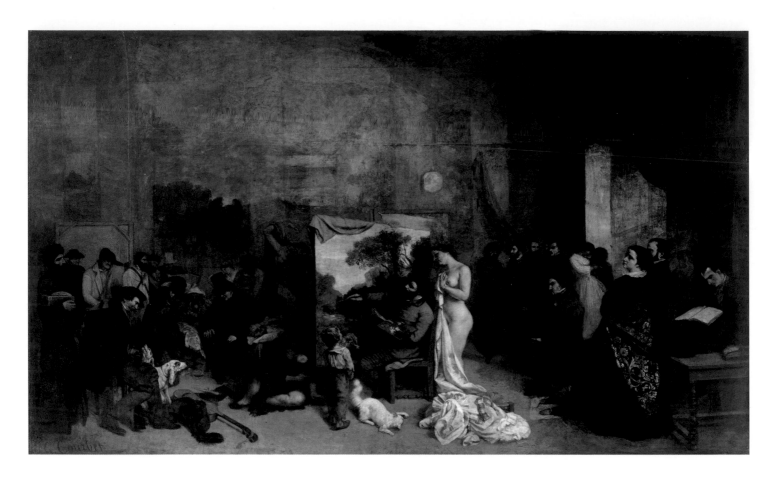

11 Gustave Courbet, *The Studio of the Painter*, 1855, Musée d'Orsay, Paris.

common, dark short-hair variety. Of a type originally imported from Turkey, this Angora looks like a specifically individual animal which a cat enthusiast might have owned. The Angora was the most luxuriant of the three domesticated breeds common in France at the time.[3] It happens that among Courbet's closest friends, and prominently featured in *The Studio of the Painter*, were two writers who were notorious cat lovers – as well as art lovers. They were Champfleury and Charles Baudelaire. Champfleury is seated behind Courbet, to the left of the well-dressed woman, and above the child who is drawing while lying on the floor. (I explain the children's presence later, since it is in a way related to pets.) Baudelaire is to the far right, engrossed in a book. To which one of them might the cat belong?

The most likely candidate is Champfleury, to whom Courbet was a closer friend and who is nearer to the cat. Champfleury wrote a book on cats entitled *Les Chats*, which he was preparing as early as 1849 although it did not appear

Gustave Courbet, *The Studio of the Painter* (detail of fig. 11).

for another nineteen years. The over-riding theme of the book is the feline's independent character. In a chapter called "Les Amis des chats," Champfleury listed poets and artists as the people most enamored of them, stating: "Those who are of a delicate nature understand cats. Women favor them; and they are held in great esteem by poets and artists, who are moved by a nervous system of exquisite delicacy."[4] Human psychology, linked to gender, was the best explanation for whether a person appreciates a cat.

Champfleury reflected the conventional wisdom of his time. In a fascinating book, *L'Esprit des bêtes: Zoologie passionelle* (1855), the science writer Alphonse Toussenel claimed that, like courtesans (beautiful women seeking to be mistresses of successful men), cats always had intellectuals and men of letters at their side.[5] This was thanks to the animal's "gentleness and refined tastes." Florent Prévost, the author of *Des Animaux d'appartement et de jardin* (1861), observed that "in spite of living in our houses, one can hardly say cats are

domesticated. [. . . Rather,] they are entirely free, they do as they please. [. . .] Their natural opposition to constraint makes them incapable of systematic education."[6]

Foremost among those who kept cats was the Romantic writer and politician François-René de Chateaubriand. In cats, he found a kindred spirit "who could flatter the master at times, but never when it infringed on his freedom." "What I love in the cat is that independent, almost ungrateful character which leads it to refuse attachment to anyone, the indifference with which it goes from society salons to its native gutter."[7] Another cat-loving author known to Courbet was Théophile Gautier, who set places at his dinner table for his pets (fig. 12).[8]

12 Nadar (Gaspar-Félix Tournachon), *Théophile Gautier and His Cats*, 1858, charcoal and white chalk on brown paper, Département des Estampes et des Photographies, Bibliothèque Nationale, Paris.

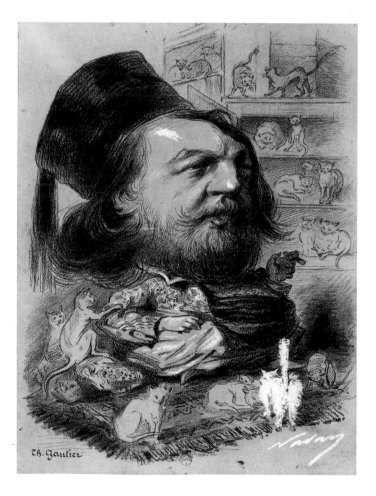

Gautier and Champfleury both claimed the cat as an emblem of political freedom, which it had symbolized during the French Revolution (1789).[9]

If Chateaubriand could claim shared character traits with cats, and Gautier and Champfleury could see them as symbols of freedom, so certainly might Courbet. During the past seven years of the painter's life – the period since 1848 to which the complete title of *The Studio* referred – he had struggled to survive without government support. Official commissions inevitably came with strings attached, and the government wielded enormous power over the arts. For example, before the 1855 exhibition in which *The Studio* was the centerpiece, Courbet had been invited to submit sketches and follow the suggestions of a committee.[10] He refused. His self-financed Realism pavilion, with a cat in the middle of its key painting, was the culmination of his effort to earn a living as an artist without giving in to any kind of control. So Courbet was using an established symbol which he

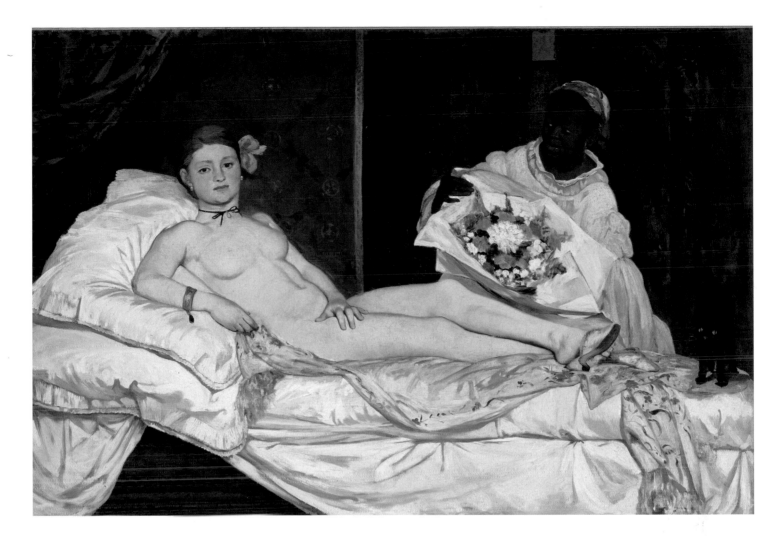

13 Edouard Manet, *Olympia*, 1862–63, Musée d'Orsay, Paris.

invested with personal meaning. The cat exemplified his modern spirit of confidence and individuality.

Another painting where the pet is far more than just a companion is Manet's *Olympia* (fig. 13).[11] Exhibited exactly ten years after Courbet's *Studio of the Painter*, it is a daring image of a prostitute, in which the cat was noticed by all. One critic actually called it "the famous painting with the black cat."[12] Newspaper cartoons always exaggerated the animal's size and posture, as in Cham's woodcut, which shows a rigidly erect tail (fig. 14). The French word for tail, *queue*, is used in slang to refer to the male penis. In addition, Cham's caption refers to the French folk tune "La Mère Michel et son chat," whose words can be interpreted as increasingly suggestive. Mother Michel, the song goes, has lost

14 Cham, *La Naissance du petit Ebéniste,*
caricature of Manet's *Olympia,*
in *Le Charivari,* 1865.

her cat. Who will help her find it? The French slang word *chatte*, which is the feminine gendered form of the word for cat (*chat*), refers to female genitalia. Need I mention the English equivalent – pussy? Whether you regard Olympia herself as erotic or off-putting, the cat confirms the painting's sexual theme. But what use was Manet making of it?

The *Olympia* is a startling transformation of the gentle, warmly alluring courtesan in Titian's *Venus of Urbino* (fig. 15). In that famous Venetian Renaissance painting, which Manet copied on a trip to Italy, a small dog lies curled up on the modest Venus's bed.[13] Dogs placed at their master's feet signify loyalty, as in medieval tomb sculpture. Titian's pup displays not just its obedience to Venus but Venus's faithfulness to the Duke of Urbino. The goddess's features are those of the duke's mistress. Manet's version is a parody: in opposition to Titian's Venus, his modern Olympia flaunts her availability to the highest bidder. The African servant, bringing an admirer's bouquet, reflects French colonial contacts with North Africa, echoing harem scenes that were popular fantasies of sexual availability.[14] The cat's gaze parallels Olympia's, brazenly meeting the eyes of the viewer/client. In the skillfully foreshortened pose that Manet gave it – back arched and stiff tail hooked – the cat faces the viewer with even more full frontal boldness than Olympia herself.

The association between cats and illicit sex went back to the Egyptians, according to Champfleury's book on cats. His (now dated) explanation was "the oriental notion that of all female animals, the cat

Edouard Manet, *Olympia,*
(detail of fig. 13).

most resembles woman in her cleverness, deceit, seductiveness, inconstancy, and fury."[15] For Toussenel, who had compared cats to courtesans, the female cat symbolized a twisted kind of love, in which the male cat was always dominated by the female. He complained that "civilized society can no more dispense with cats than with prostitution," and "all is not rosy in those shameful loves symbolized by the cat."[16]

One who shared similar impressions, though more refined, was Charles Baudelaire, the other notoriously cat-loving friend in Courbet's *The Studio*. Baudelaire was also a confidant of Manet. Many were the sexual allusions in his collection of poems *Les Fleurs du mal*, published in 1857. (Shortly after publication, Baudelaire was arrested for offense to public morality. He was fined, and six poems were removed.) In several of these pieces, cats are associated with female lovers. In one Baudelaire compared cats to sphinxes, with their connotations of exotic mystery.[17] Another begins: "Come, my beautiful cat, on to my loving heart;/ Retract the claws from your paw,/ Let me lose myself in your beautiful eyes."[18] A third describes the cat's soothing purr: "It relieves the

15 Titian, *Venus of Urbino*, 1538, Galleria degli Uffizi, Florence.

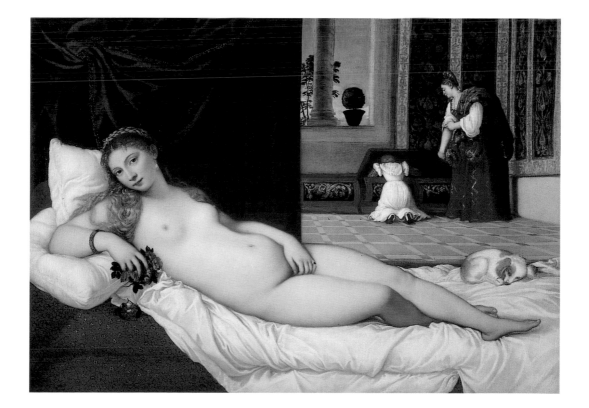

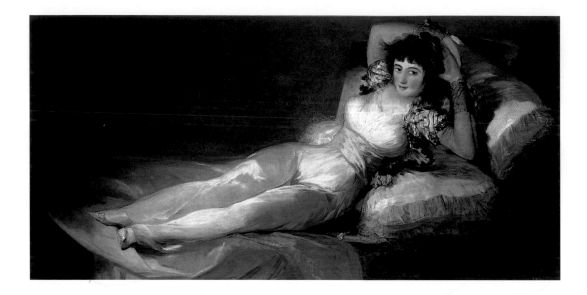

16 Francisco de Goya, *Clothed Maja*, 1795, Museo del Prado, Madrid.

cruelest evils/ And contains every ecstasy;/ To say the longest phrases,/ It needs no words at all."[19] For Baudelaire, sex, poetry, and art were ways to escape the routine of everyday existence. Cats were associated with all three.

For Baudelaire, like Courbet, Champfleury, and Gautier, the cat was also a symbol of artistic independence. But Baudelaire's ideas were more complex than theirs, because he recognized the economic constraints on artists. In a passage of his essay *Le Peintre de la vie moderne* (published in 1863, while Manet was painting his *Olympia*), Baudelaire compared artists with courtesans, the kind of ladies associated with cats. He described the aesthetic sensitivity and fashion-consciousness which characterizes such women of the world. He implied that their eye for beauty, based on the need to attract attention and satisfy male desire, paralleled the artist's eye.[20] In addition, both artists and prostitutes are subject to financial necessity. So both are forced to rely on a fickle clientele for survival, and both manipulate appearances in order to succeed.

Olympia is thus a kind of *alter ego* for Manet, whose art confronted the public, baring unpleasant truths to general exposure. A cartoon by Bertall refers to Olympia as "Manette," which, besides being a play on "Manet," combines the artist's name with "Minette," a common name for cats.[21] Like Courbet's *Studio of the Painter*, the *Olympia* thus relates to the claim of artistic independence, which its boldness exemplified. Yet despite his sexual provocation, Manet's interpretation is more subtle that Courbet's. He recognized that the

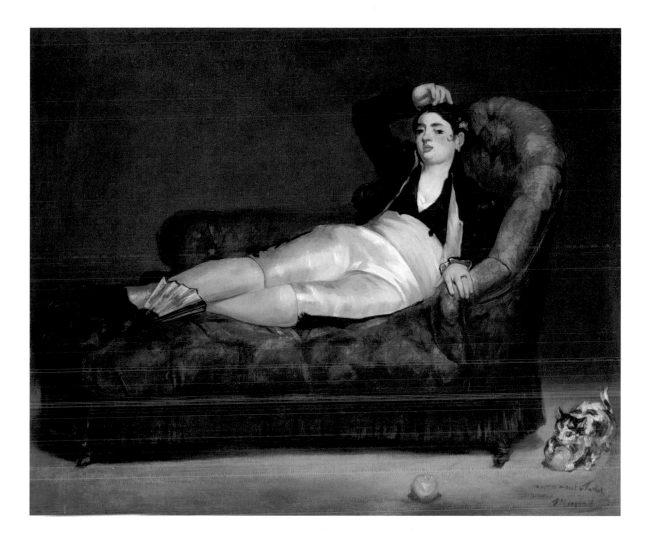

17 Edouard Manet, *Young Woman Reclining, in a Spanish Costume*, 1862, Yale University Art Gallery, Bequest of Stephen Carlton Clark, B.A. 1903.

artist's freedom is limited, like the cat's, by dependence on public indulgence and support. So the cat, even more than Olympia herself, was the artist's *alter ego*, a symbolic stand-in.

In fact, during the 1860s, the cat was a frequent motif throughout Manet's work. One important example was an obvious forerunner to *Olympia*. This was his portrait of the mistress of the notorious photographer Nadar (Gaspard-Félix Tournachon) dressed in trousers. The painting, entitled *Young Woman Reclining, in a Spanish Costume* (fig. 17), includes a cat at the lower right – this time a rambunctious kitten.[22] The painting made an obvious allusion to Francisco de Goya's *Clothed Maja* (fig. 16), in which Goya represented his former mistress

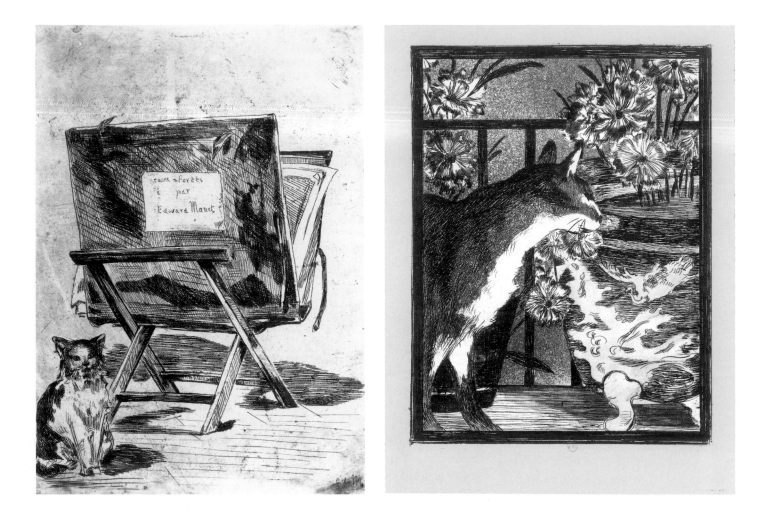

18 Edouard Manet, first cover design for *Eaux-fortes par Edouard Manet*, 1862, etching, New York Public Library.

19 Edouard Manet, *Cat and Flowers*, 1869, etching and aquatint, Département des Estampes et des Photographies, Bibliothèque Nationale, Paris.

as a courtesan. (Goya made a second, more famous version of the composition in which she is represented in the same brazen pose, stark naked.) So the identity of Manet's trouser-wearing, gender-bending figure as a woman of dubious status left no doubt. Nor is the cat's presence a surprise, given its incorrigible habits. The picture was a dress(ed) rehearsal for *Olympia*.

As Theodore Reff first noted, in a series of etchings done at the same time as *Young Woman Reclining*, Manet toyed with groups of objects and figures that symbolize the artist and his craft.[23] For example, he wanted to make a cover page for an album of prints that he planned to market. In an early version, he placed a cat standing proudly beside an artist's portfolio (fig. 18), almost as though staking its territory, its personal ownership, or even authorship. Here,

more obviously than in *Olympia*, the cat is a surrogate for the artist. In the image Manet eventually used for his cover, however, he substituted a still life to stand for the artist's creative process. Still life is an arrangement of forms into an aesthetically pleasing or otherwise meaningful composition. It exemplifies the act of artistic composition, and it was an important training exercise for artists. Then, in a etching *Cat and Flowers* (fig. 19), Manet combined the cat as symbol of the artist with a bouquet – a floral still life alluding to artistic arrangements of beautiful forms.

The oranges in Manet's *Young Woman Reclining* certainly refer to Spain, while they also function as still life. Combined with the cat, the reference to both the artist and the artistic activity of composition-making is complete. The cat here is remarkably playful, its mischief with the fruit exemplifying Manet's artistic wit. Manet often engaged playfully and ironically with forms and conventions. And it is no accident that there is more lively brushwork for the cat than elsewhere in the picture, or

Edouard Manet, *Young Woman Reclining, in a Spanish Costume* (detail of fig. 17)

that the cat is just above the artist's name in the dedication to Nadar. Both the brushwork and the cat on which he used it were like a "signature" – aspects of Manet's repertory and style as distinctive as his handwriting.[24]

In a later large painting, *Le Déjeuner dans l'atelier* (fig. 20), Manet placed a cat in the artist's studio.[25] Conceived while Manet was in rented summer quarters at the Channel resort of Boulogne, it is a more naturalistic scene than Courbet's *Studio*, and a less provocative one than *Olympia*. With the cat are other attributes of artistic study. The helmet and sword are props, and the potted plant is a still life. It thus concludes the series in which Manet juxtaposed cats and objects to allude to art. At this time, Manet had also produced the *Cat and Flowers* etching as an illustration for Champfleury's *Les Chats*, which was finally being published and for which he did a poster (fig. 21) to advertise the book. In the latter, a black cat recalling the one in *Olympia* stalks a white

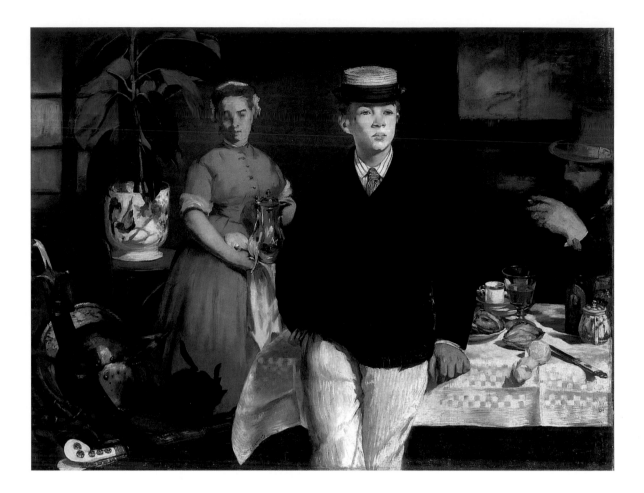

20 Edouard Manet, *Le Déjeuner dans l'atelier*, 1868, Bayerische Staatsgemäldesammlungen, Munich.

one across a rooftop. Is this Olympia's cat versus Courbet's? At least the sexual allusions are confined to the animal world.

Among the illustrations in Champfleury's book are two by Edmond Morin that merit attention. One shows Champfleury himself looking as if he has grown cat ears (fig. 22a). Behind him on a row of books sits a white kitty. I suspect it is the Angora painted by Courbet. The other represents Baudelaire (fig. 22b) contemplating a cactus in a planter – a reference to the prickly poems in *Les Fleurs du mal*, as indicated by some writing on the planter. Perched on the poet's shoulder, with arched back and crooked tail, is a cat of mixed coloring, perhaps a reference to Baudelaire's mulatto mistress, as well as to his poems on cats. From Courbet's image of 1855 to Champfleury's book of 1868, then, the artist's cat was a common reference to the creative avant-garde and its libertarian challenges to tradition.

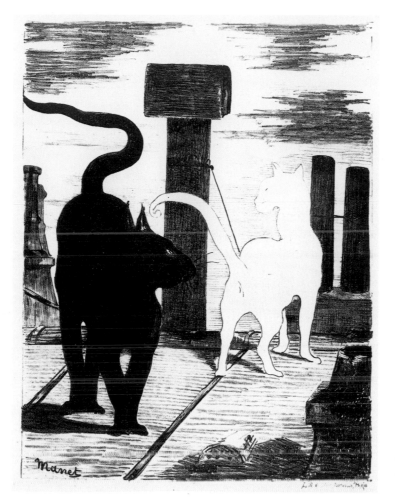

21 (*left*) Edouard Manet, *Cats' Rendezvous*, 1868, lithograph, New York Public Library.

22a (*below left*) Edmond Morin, *Champfleury*, etching, in Champfleury, *Les Chats*, Paris, 1868.

22b (*below right*) Edmond Morin, *Charles Baudelaire*, etching, in Champfleury, *Les Chats*, Paris, 1868.

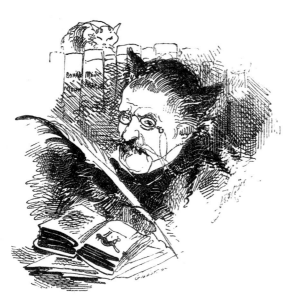

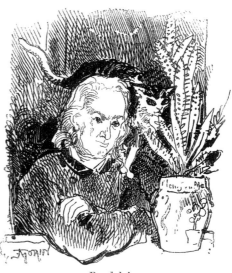

Baudelaire.

The Painter's Best Friend

Thanks to his many hunting scenes, Courbet was known as one of the best animal painters of his time. *The Studio of the Painter* is one of very few in which he showed a cat, and it is the sole self-portrait where he included one. But he made no bones about his love of dogs; this cat is more a symbol than a pet.[26] Dogs are present in at least two other self-portraits, where they are more natural than symbolic but still convey considerable meaning. (The two dogs on the left side of *The Studio* belong to the hunter seated beside them and so are not directly associated with the artist.[27]) The first is the magnificent early *Self-Portrait with Black Dog* (fig. 23). On a rocky hilltop overlooking a lush green valley sits the young artist with his shiny-coated spaniel displayed prominently beside him. The dog's posture mimics his master's self-conscious pose, the long ears echoing Courbet's ample locks of curly auburn hair. Courbet is dressed as a dandy, with fashionable plaid trousers, a brightly lined jacket of black velvet, and a wide-brimmed hat. Behind him are a walking-stick and sketchbook. Pet dogs, except for the very smallest, need the out-of-doors. In that, they are like modern artists, nourished by the direct experience of nature. What better companion, then, for such an artist along his walks? In this scene, Courbet has put down the sketch-book and taken out a pipe – a possession included in several other self-portraits.[28] The act of smoking creates a pause in other physical activities, one which emphasizes the contemplation associated with artistic imagination. Who but a faithful dog, with all the patience in the world, is better to share the artist's suspended time? Unlike the fidgety cat in Courbet's *Studio*, the dog is quiet and attentive. His presence highlights the artist's meditative solitude.

Another sort of dog appears in Courbet's *The Meeting: Bonjour Monsieur Courbet* of 1854 (fig. 24). Here, the artist encounters his new private patron, Alfred Bruyas, a banker's son from the southern town of Montpellier.[29] (Bruyas is in the back row of figures in *The Studio*, fig. 11.) In this painting, done just before *The Studio*, it is Bruyas who is accompanied outdoors by a faithful Poitou or Saintonge hound, a breed popular in the South of France. Courbet wanted to celebrate a relationship with Bruyas, whom he hoped would finance his independence from government patronage. He cast himself in the role of itinerant artisan, carrying equipment on his back – like a rustic version of today's free-lance artist, Apple Powerbook in hand, meeting an employer.[30] Courbet is certainly the dominant force; Bruyas is cordial and deferential, his valet completely subservient. The dog is an excellent barometer of the situation. He stands his ground respectfully, with neither the wariness nor the salivating enthusiasm that

facing page Gustave Courbet, *Self-Portrait with Black Dog* (detail of fig. 23).

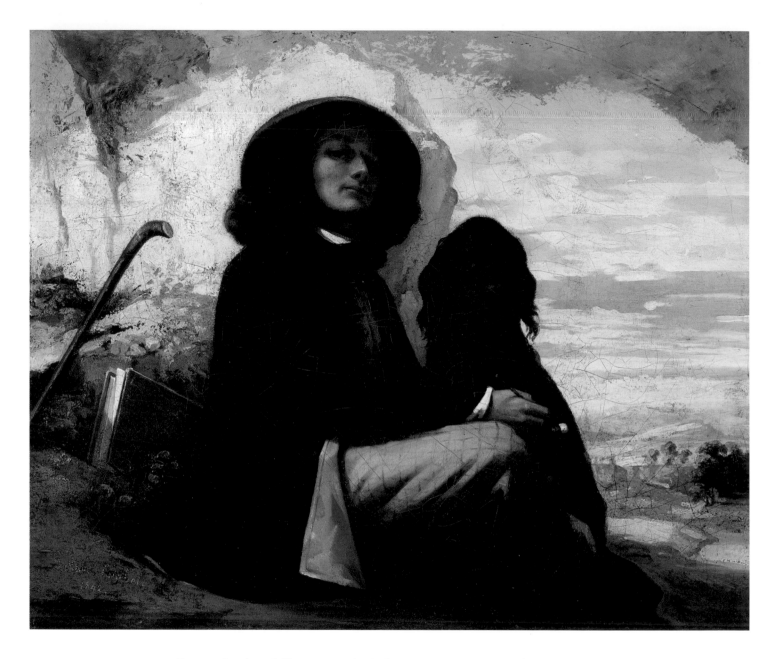

23 Gustave Courbet, *Self-Portrait with Black Dog, c.* 1842–44, Musée du Petit Palais, Paris.

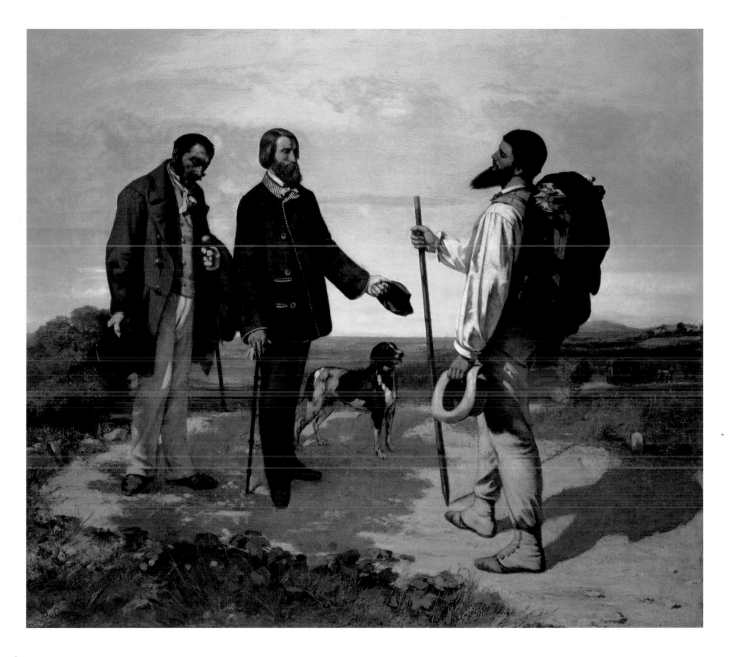

24 Gustave Courbet, *The Meeting: Bonjour Monsieur Courbet*, 1854, Musée Fabre, Montpellier.

Gustave Courbet, *The Meeting: Bonjour Monsieur Courbet* (detail of fig. 24).

dogs often show when greeting newcomers. His anticipation is honest and friendly, in a way that suggests both the power and beneficence of Courbet's presence. A facetious cartoon of the painting (fig. 25) shows all three characters, counting the canine, kneeling before Courbet. The caricaturist called it "a Realist imitation of the adoration of the Magi," perhaps alluding to Courbet's hidden aspiration. However, the reputed honesty of dogs and their uncanny ability to read even disguised intentions made Bruyas's pet a useful argument for Courbet's sincerity.

Dogs were so associated with Courbet that the young Monet – in perhaps his only painting of an animal other than in a rare portrait[31] – placed one near

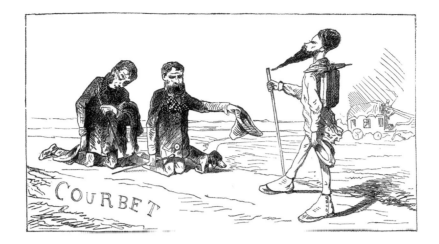

25 Quillenbois, *The Adoration of Monsieur Courbet: A Realist Imitation of the Adoration of the Magi*, caricature of Courbet's *The Meeting: Bonjour Monsieur Courbet*, from *L'Illustration* July 21, 1855.

Courbet in his painting *Le Déjeuner sur l'herbe* of 1865 (fig. 26). Courbet, who was friendly with Monet, is the figure stretched out in the painting's right foreground. Another painter friend, Frédéric Bazille, is present, as is Monet's mistress, Camille Doncieux. The dog is actually a reverse quotation (with a change of breed, explained in chapter 3) from another giant painting by Courbet, *A Burial at Ornans* (fig. 27). The latter was the work through which Courbet first became notorious for challenges to the art establishment. There, assembled at the local cemetery, the citizens of Courbet's home village of Ornans lay one of their own to rest.[32] The dog twists its head around to watch the figures in the funeral cortege move off to the right before closing the circle around the grave. The many homely aspects of *A Burial at Ornans* subverted conventional religious idealizations of death in favor of everyday reality. One of them was Courbet's common touch of the distracted dog. For Monet, the animal embodied this down-to-earth element of Courbet's reputation, while affirming the artist's association with companion animals.

Monet's *Déjeuner sur l'herbe* contrasted markedly with pictures by Manet – with whom Monet was often confused at the time because of the similarity of their surnames. In the 1860s, Monet wanted to present himself as a painter of the countryside. Manet's imagery was generally more urban. So Monet's luncheon gathering of friends at the forest's edge made a distinction from the sophisticated assembly of the Parisian intelligensia presented in Manet's *Music*

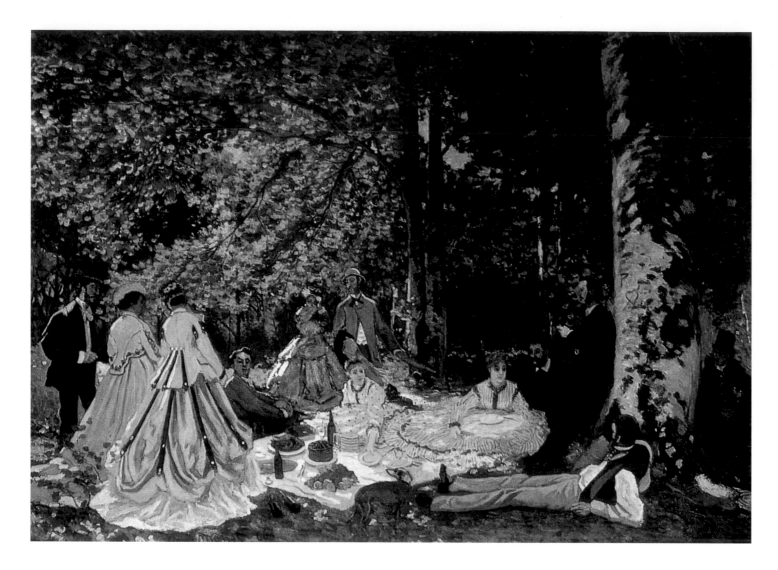

26 Claude Monet, Sketch for *Le Déjeuner sur l'herbe*, 1865, Pushkin Museum of Fine Arts, Moscow.

in the Tuileries Gardens (fig. 28). With the latter, exhibited in 1862, Manet presented himself as a painter of modern Paris life.[33] Monet placed himself outside the city. He probably noticed the toy dog, perhaps a poodle, with a ribbon in its hair on the chair next to two fashionable ladies in Manet's foreground. What better counterpoint to Manet than to echo Courbet's more rustic pet rather than Manet's city lapper?

Monet's Impressionist friend Pierre-Auguste Renoir also used the artist-companion theme, looking back again to Courbet and Manet as Monet had. A wonderful white poodle is in the foreground of Renoir's early portrait of artist-bohemian comrades at *The Inn of Mother Antony* (fig. 29), painted at a tavern

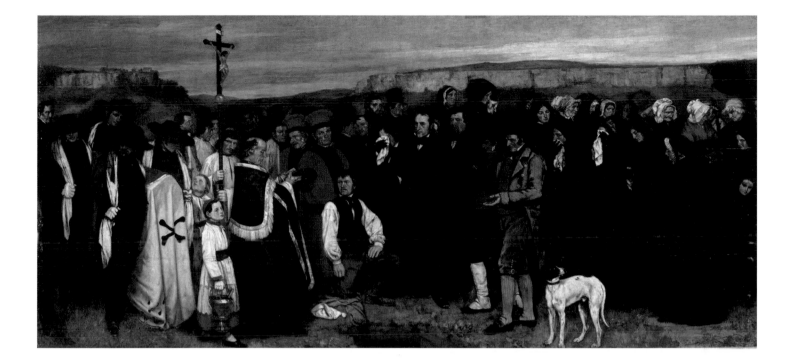

27 (*above*) Gustave Courbet,
A Burial at Ornans, 1849–50,
Musée d'Orsay, Paris

Gustave Courbet, *A Burial at
Ornans* (detail of fig. 27).

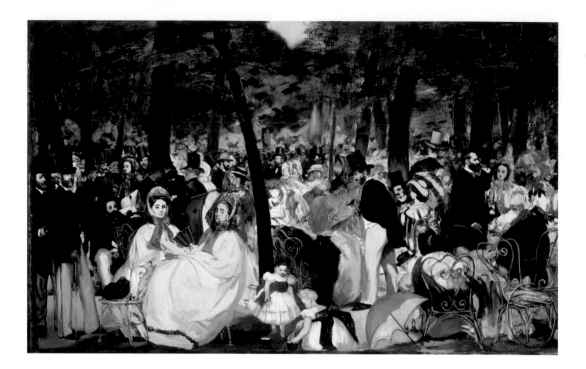

28 Edouard Manet, *Music in the Tuileries Gardens*, 1862, National Gallery, London.

near Marlotte.[34] Following Monet's *Déjeuner sur l'herbe* by only a year, it reflects Courbet in a different and perhaps deeper way than Monet had. The Renoir clearly echoes Courbet's early painting *After Dinner at Ornans* (fig. 30), which shows friends and family after a country meal listening to a violinist. Through this painting, Courbet wistfully identified himself with rural ways and rustic culture. A mastiff lying in the foreground, perhaps a Bordeaux breed, contributes a homely touch. And just as the Renoir looks back to the Courbet, Courbet referred back farther. Through its general type, position in the picture, and the dark realist style in which it was painted, Courbet's curled-up cur paraphrased the famous royal mastiff in Diego Velázquez's *Las Meninas* (fig. 31).

In their first years, the Impressionists often painted in rural areas such as Marlotte, near the Fontainebleau Forest. They supped and socialized at spots like Mother Antony's, which was also a cabaret. Camaraderie and carousing among young artists was a way of bolstering confidence and identity. By showing his artist-colleagues Jules Le Coeur (standing) and Alfred Sisley (wearing the hat) at a place like this (fig. 29), Renoir positioned himself within the traditions of outdoor painting that led to full-fledged Impressionism; the third man is tentatively identified as a Dutch painter companion. Like Courbet,

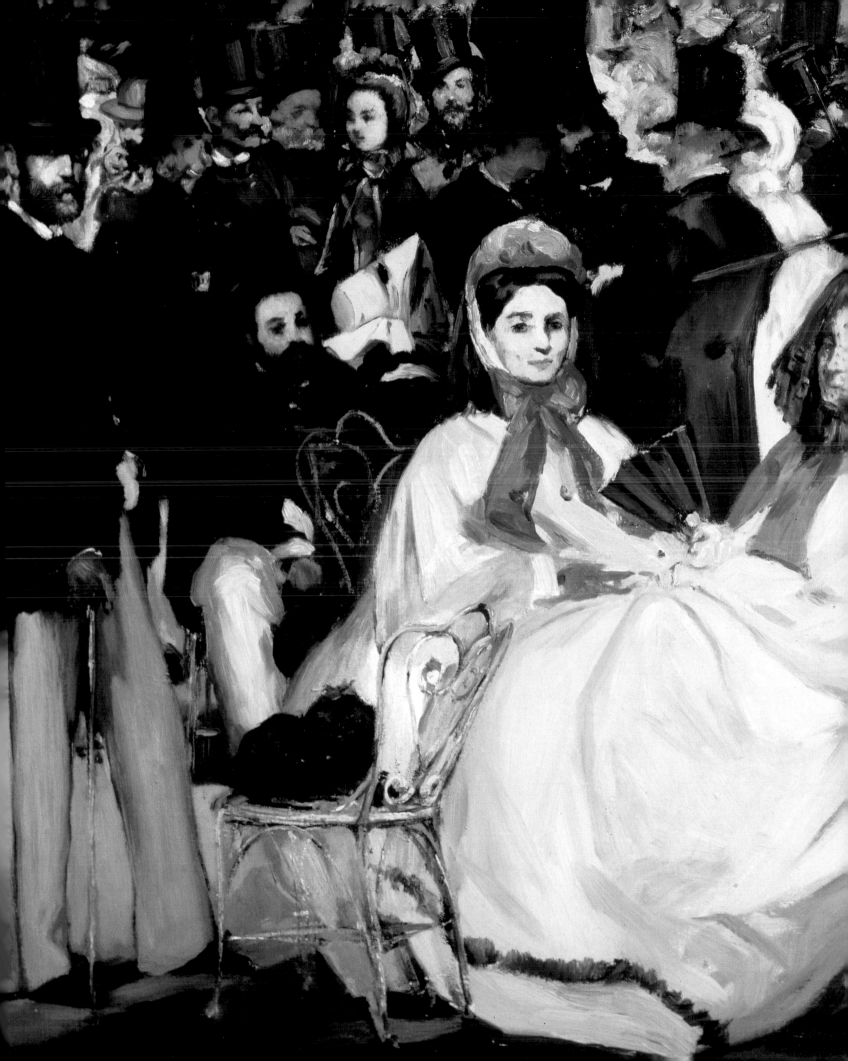

29 Pierre-Auguste Renoir, *The Inn of Mother Antony*, 1866, Nationalmuseum, Stockholm.

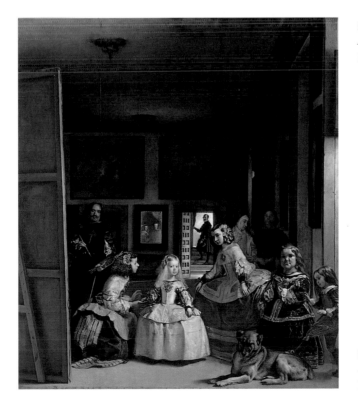

30 (*above*) Gustave Courbet, *After Dinner at Ornans*, 1848–49, Musée des Beaux-Arts, Lille.

31 Diego Velázquez, *Las Meninas*, 1656, Museo del Prado, Madrid.

32 Pierre-Auguste Renoir, *Jules Le Coeur in the Forest of Fontainebleau*, 1866, Museu de Arte Moderna, São Paulo.

facing page Pierre-Auguste Renoir, *The Inn of Mother Antony* (detail of fig. 29).

Renoir identified with certain friends and a specific region. Le Coeur, as in another painting of 1866 by Renoir (fig. 32), had at least three dogs. Perhaps one of those shown with him in the forest is the one gazing out from Renoir's group portrait at the inn. Le Coeur lived nearby, where he hosted Renoir and others, and he could certainly have brought a poodle with him. On the other hand, Renoir's scene includes a waitress known as Nana and, in the background, an older woman who is presumably Mother Antony herself. It is equally possible that the dog belonged to the establishment. Renoir remembered its name as Toto and said it had a wooden leg.

In many of these group portraits of artists and friends, the canine presence seems at first like a trivial element of naturalism. But that is not to say it has no meaning. In *The Inn of Mother Antony*, the dog lacks the obvious significance of Courbet's spaniel, his companion on walks and an attribute of his early dandyism. But it provides a common touch, enhancing the inn's

home-like coziness, just as the sketching and scribbling on the wall behind the group suggest Mother Antony's open-hearted relationship to her artist-clients. The dog's watchful gaze contrasts with the varied focal points of the picture's human figures. Nana inelegantly clears the table, piling up cups and dishes. Le Coeur takes out his tobacco pouch and makes ready with cigarette paper to roll a smoke. Gesturing as he speaks, Sisley and the third figure discuss an article in *L'Evénement*, the liberal newspaper which published articles defending Manet's *Olympia*. Lacking overt symbolism, the dog therefore differs from the cats of Courbet's *Studio* and Manet's *Olympia*. It is a simple expression of the matter-of-fact, down-to-earth reality of artists' daily lives.

These paintings thus establish an alternative pattern of animals as artists' companions. All these dogs, as far back as Velázquez, share a role in defining the artist's image through realistic domestic settings. Velázquez was proud to

show himself as part of the inner royal circle, including the princess, her attendants and dwarves, with the King and Queen of Spain reflected in the mirror on the rear wall of the palace studio. Courbet was proud to display his provincial roots. Renoir put himself in a time-honored place where landscape artists gathered. So Renoir was far from painting in a vacuum, even though he insisted on originality. The fixed gaze and attentive look of his dog, as well as its specific breed – an unclipped standard poodle needing a bath – suggest a portrait as precise as those of Renoir's friends. By contrast, Courbet and Velázquez represented more generic animals, even if they could be portraits in fact. By acknowledging the presence of someone observing, Renoir's dog makes the scene a specific event in real time rather than a more generalized view. Yet, with its heritage extending back in history, Renoir's painted poodle affirms the high ambition of what at first seems lowly realism.

The Artist as a Rover

You enter Gustave Caillebotte's powerfully geometric *Pont de l'Europe* (fig. 33) through the eyes of a man walking his dog. You assume the dog is accompanied because of its position in the picture, as in Caillebotte's *Richard Gallo with His Dog Dick at Petit Gennevilliers* (fig. 34), where a poodle leads the way on a stroll.[35] The Pont de l'Europe was the new cast-iron bridge over the railroad yards of the Saint-Lazare train station.[36] Behind it was the most modern of Paris neighborhoods, in which the well-to-do Caillebotte comfortably resided (as did Manet). The painting celebrates the straight lines of rational urban design and structural engineering imposed over the old haphazard city by Emperor Napoleon III's demolition and reconstruction program.[37] The results of that urban renewal were the wide boulevards characteristic of today's Paris. These were thoroughfares which in their day introduced light and free-flowing circulation, as shown here, to a previously congested urban complex.

One of the delights of such spaces was the activity of what the French call the *flâneur* – an individual who strolls about in a leisurely manner while observing passers-by. As in Degas's *Place de la Concorde* (fig. 49) the *flâneur* might be accompanied by a dog. But in Caillebotte's picture the dog belongs to an unseen stroller. Although the animal's fur makes it hard to see the collar in *Pont de l'Europe*, it is clearer in a sheet of studies for the painting.[38] A stray or "bohemian" dog without a collar, hence without a master, would have less purposeful movement and would be unlikely in this prosperous part of town.[39]

facing page Gustave Caillebotte, *Pont de l'Europe* (detail of fig. 33).

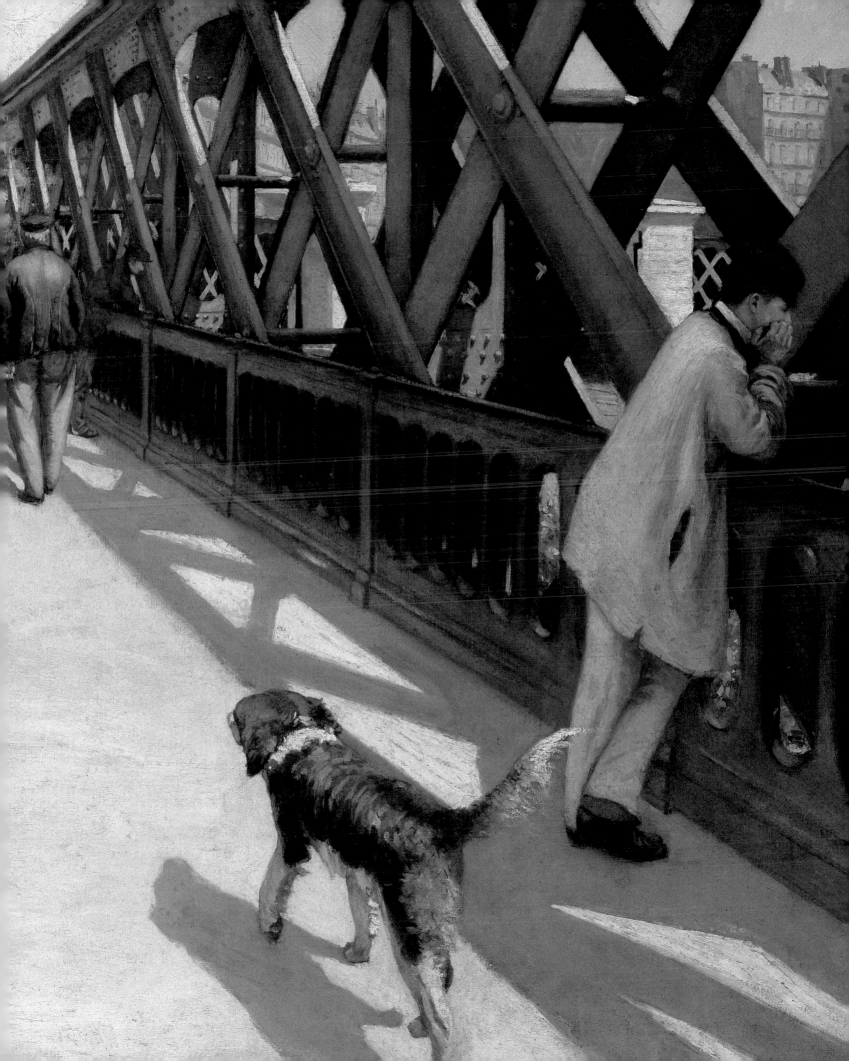

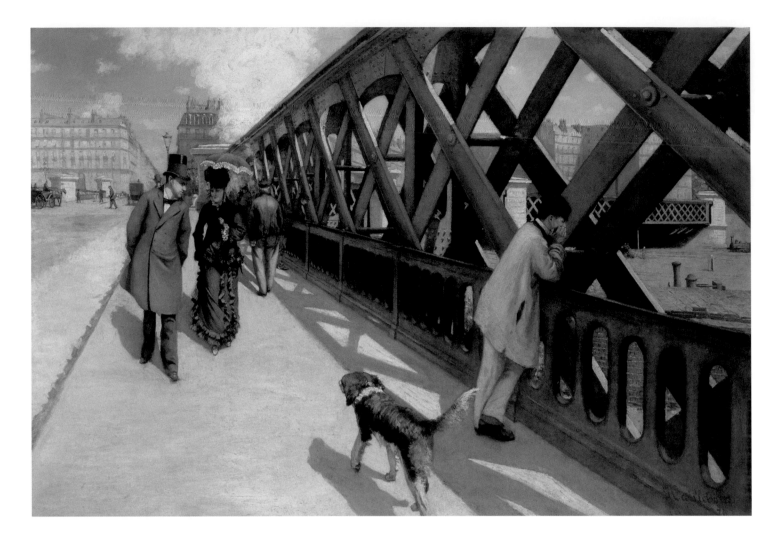

33 Gustave Caillebotte, *Pont de l'Europe*, 1876, Musée du Petit-Palais, Geneva.

The emphatic perspective that rules Caillebotte's picture creates a tension between the rushing space of motion and a freeze-frame-like stillness – two aspects of a fast-shutter camera, as in a pre-cinematic effect.[40] The dog, which is of some sporting breed or mix, embodies this tension better than any other figure in the picture. For one thing, it is closest to the viewer, and its body exactly parallels the shadow cast by the iron girders as they lead the eye into depth. But in addition, the dog's posture creates its own odd double reading. Understood in movement, it sets the pace of the viewer's promenade. Understood as still, it alludes to the canine hunting instinct. It adopts the pointing position well known to sportsmen and often illustrated in books on animals,

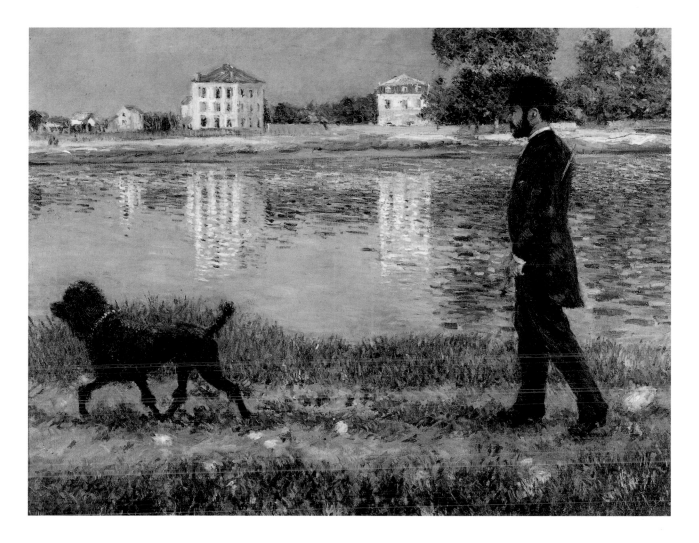

34 Gustave Caillebotte, *Richard Gallo with His Dog Dick at Petit Gennevilliers*, 1878, private collection.

including Darwin's treatise on human and animal emotion (fig. 35), where the dog has smelled a cat. The raised tail and bent foreleg are telltale elements of this pose, which Caillebotte – a sportsman himself – noted precisely.

Is the dog's walker the artist? Those who knew Caillebotte might have recognized him as the model for the approaching man. He has just passed by a woman, turning his head to acknowledge her in what one critic termed "a little game which all of us have observed."[41] The critic knew that women unaccompanied in the street were probably not of respectable class. Her dress is just a bit too fancy. So whose dog has spied her? Ladies were associated with lap dogs, not hunting breeds. The solitary dog-walker/*flâneur* would be male by defini-

tion, and his roving eye was one the woman might be hoping to engage. This is a man's hound pointing out its prey, expressing in its explicit vocabulary an urban version of the hunter on the prowl. A lithograph from Daumier's *Journée du célibataire* series offers a relevant comparison (fig. 36). Monsieur Coquelet is walking his dog, whose position indicates he has sensed a target. In the next plate, the dog sniffs up the tail of the receptive bitch.

For artists who worked in an urban setting, such as Manet, Degas, and Caillebotte, the gaze of the *flâneur* was an important model for the artist. In his essay *Le Peintre de la vie moderne*, Baudelaire praised dispassionate detachment and the almost detective-like ability of the artist-*flâneur* to analyze the social status and psychological situations of the subjects of his glance, while passing briefly by.[42] Placing himself explicitly within his painting, Caillebotte used the tradition in which artists define their vision in the company of pets. The comparison with Manet's *Olympia* seems most pertinent. For if Manet ironically echoed Baudelaire's parallel between art and prostitution, Caillebotte, while remaining in a related sphere of sexual relations, preferred to emphasize the inquisitive male eye. Alongside Caillebotte's machismo in this picture is his insistence that his animal symbol be a hunting dog rather than a sassy cat.

In Manet's portrait of Marcellin Desboutin, entitled *The Artist* (fig. 38), Desboutin's sandy-colored, setter-like spaniel slurps from a glass on the floor.[43] Desboutin was a friend of several Impressionists, and he showed with them in 1876. He is also the figure whom Degas had pose for his famous painting *In a Café*, better known as *Absinthe* (fig. 37), where Desboutin is accompanied by the actress Ellen Andrée.[44] In both paintings, Desboutin has his pipe. In the Manet, he has just returned from a stroll – he tucks his walking-stick under his left arm as he opens a tobacco pouch. Following their promenade, the dog

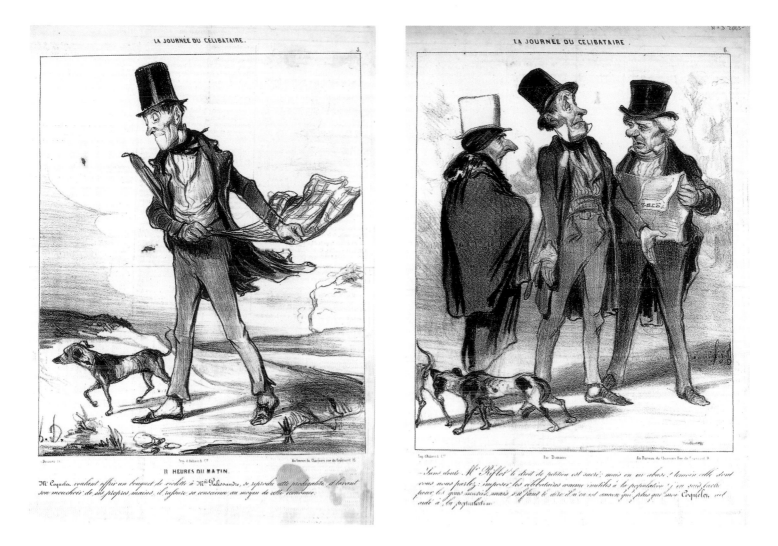

36a and b Honoré Daumier, *M. Coquelet, voulant offrir un bouquet de violette à Mlle. Palisandre . . .*,
and *Sans doute M. Riflot le droit de pétition est sacré . . .*, lithographs, 1839 .

requires a drink, the artist, a smoke. In *Absinthe*, Degas showed Desboutin
gazing ahead from a window seat at the Nouvelle-Athènes café. His position is
that of the artist-*flâneur* whose mobility is temporarily suspended or has yet to
begin. Dressed in shabby elegance, Desboutin fits the mold of the artist as
bohemian dandy. In the Manet, Desboutin's canine companion lends some
practical idea to the facts of the artist's identity and daily life. As such, it looks
back to Courbet's *Self-Portrait with Black Dog* (fig. 23), of which it is an urban
version. Although he records a modern life shared by many, the artist is a loner,
accompanied only by a dog, who in such cases is the emblem of that solitude.

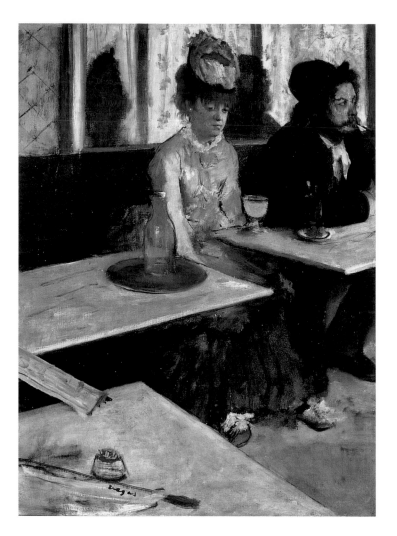

37 Edgar Degas, *In a Café*
(*Absinthe*), 1875–76, Musée
d'Orsay, Paris.

Time after time, the association between pets and artistic identity is
inescapable. In this case, with its instinctive thirst and the viewer's inelegant
viewpoint from behind and almost below, Desboutin's dog suggests more than
is clear at first glance. Discarding his earlier complexities and symbolism, Manet
here aligned himself with Desboutin and the Impressionists by appearing to
take directly from everyday life. Nowhere is his approach better embodied than
in the exuberant sketch-like brushwork of the canine. One critic claimed it was
worthy of the great Velázquez – again used as a measure of the ability to make
art of great vivacity and beauty from a humble source.[45] In this sense,
Desboutin's dog is the successor to Nadar's mistress's cat. Both embody ideas
about artists despite their natural presence as pets, while displaying the signa-
ture playfulness and skill of the artist's brush.

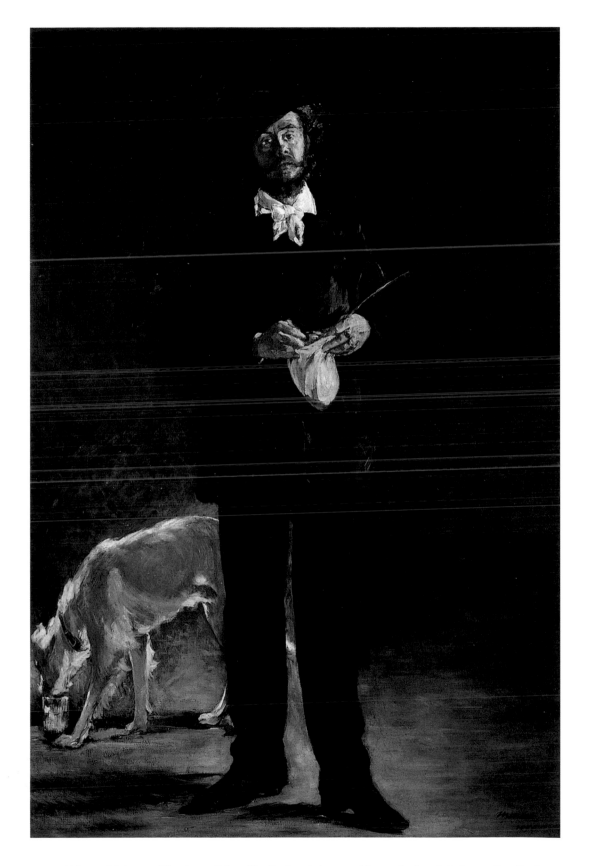

38 Edouard Manet, *The Artist (Marcellin Desboutin)*, 1875, Museu de Arte Moderna, São Paulo.

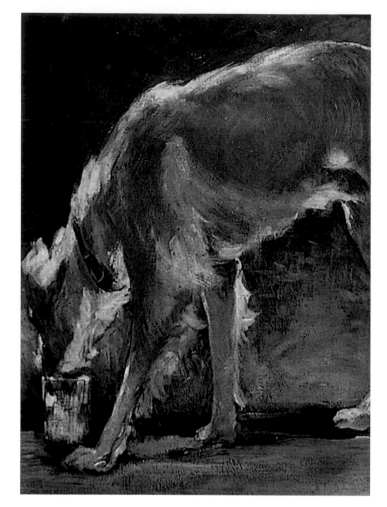

right Edouard Manet, *The Artist (Marcellin Desboutin)* (detail of fig. 38).

39 (*facing page*) Georges Seurat, *A Sunday Afternoon on the Island of La Grande Jatte*, 1886, Art Institute of Chicago.

Georges Seurat's *A Sunday Afternoon on the Island of La Grande Jatte* (fig. 39) is of an entirely different order from Impressionist spontaneity and emphasis on the moment; note his prominent placement of a black mongrel at the center of the composition, for example. In 1886, about twenty years after the Impressionists first met and twelve years after their first exhibition, the considerably younger Seurat hoped to reform Impressionism. He opposed its focus on what he thought were superficial and transitory aspects of life in favor of what he believed were lasting underlying truths. His pointillist technique, methodically applying paint in dots and dashes, was meant to "synthesize" many different moments of time into a single, permanently frozen image.[46] Seurat's choices of pets can be judged in the light of such ambitions. On a day of leisure on the long, narrow island in the middle of the Seine just north of Paris, a cross-section of middle-class society appears. The picture is the Seurat generation's version of

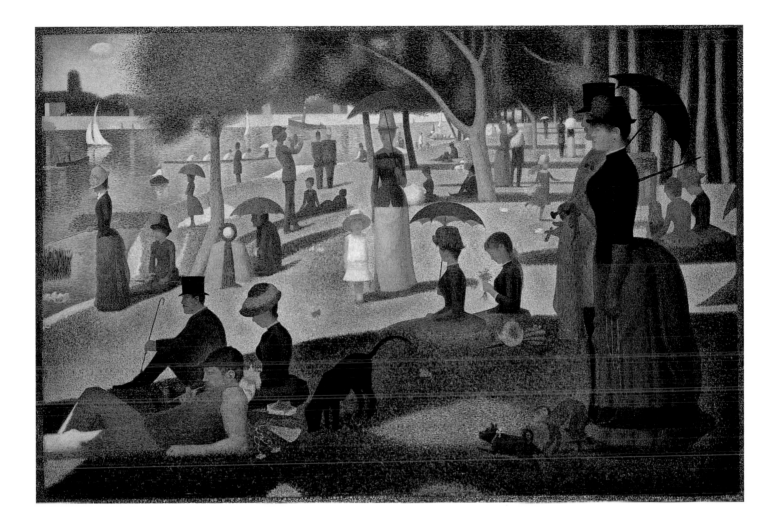

La Grenouillère (figs. 57–61). Mothers and daughters mix with elegant couples, such as the gentleman with his mistress to the right. The monkey on a leash – an exotic pet in almost any society – indicates the woman's status as a courtesan spoiled by her lover. The frilly little pug with a ribbon probably belongs to her as well. It frolics towards its larger cousin, who purposefully sniffs the ground, as serious dogs will do.

In one study for *La Grande Jatte*, the larger, central dog is the sole figure in a deserted landscape (fig. 40).[47] This drawing is the basis for a theory of the dog's symbolism, based on the intuition that it is homeless. Richard Thomson has described how, in art and literature, there was a tradition of the stray dog representing the interloper, hooligan, and insurgent who upsets conventional social structures.[48] Seurat's mongrel fends for itself in a society which places too great a value on social rank and breeding. That it lacks the usual collar may

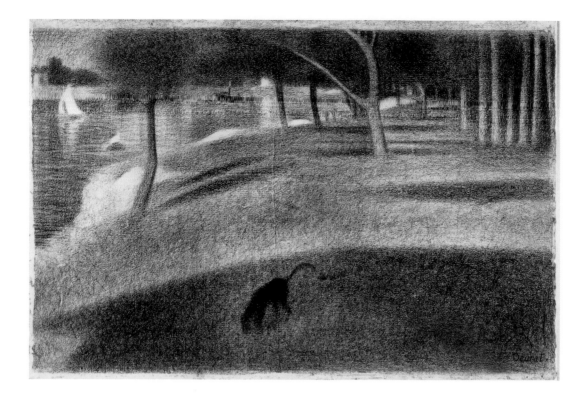

40 Georges Seurat, Drawing of a dog for *La Grande Jatte*, conté crayon, *c.* 1884–85, Trustees of the British Museum, London.

even suggest its freedom, although in an earlier work by Seurat (*Bathers at Asnières*, 1883–84, National Gallery, London) a collarless russet spaniel clearly belongs to the man next to whom he nestles. Perhaps unregistered dogs are simply the mark of their poorer, tax-evading owners. (Compliance was around eighty per cent. An aim of taxation was to reduce the number of poor people's dogs, considered more susceptible to disease.[49])

From this point of view, Seurat's black dog, whether belonging to someone nearby or not, offers a sharp contrast both in class and demeanor to the courtesan's pets. This interpretation fits with Seurat's reputedly leftist politics. The irony is that, despite his wish to make a contrast with the more bourgeois-oriented Impressionists, Seurat still availed himself of the thirty-year long practice of using animal presences to convey artistic aims. For *La Grande Jatte* was Seurat's artistic manifesto, echoing Courbet's *Studio of the Painter*, Manet's *Music in the Tuileries Gardens* and *Olympia*, Monet's *Déjeuner sur l'herbe*, Renoir's *Inn of Mother Antony*, and Caillebotte's *Pont de l'Europe*. All these were paintings in which artists proclaimed the originality of their vision while

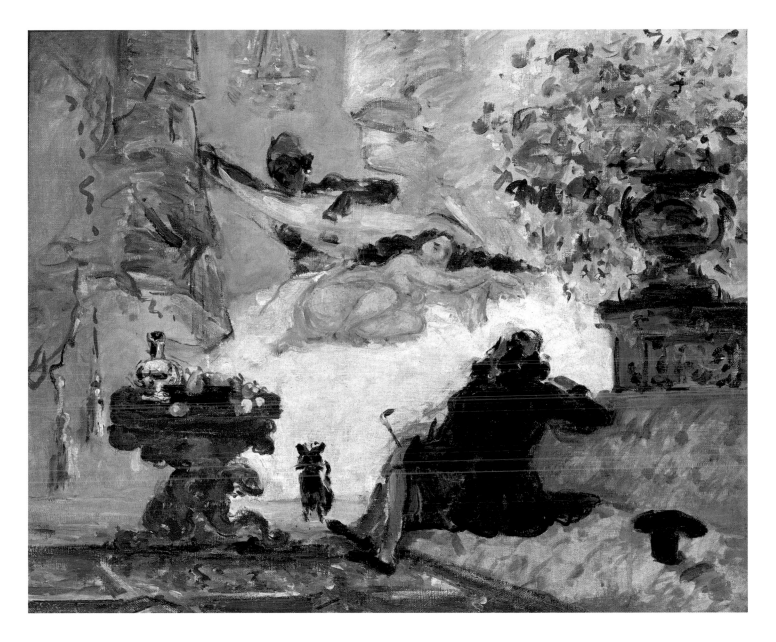

41 Paul Cézanne, *A Modern Olympia*, 1873, Musée d'Orsay, Paris.

in the company of pets. Aligning himself with the mongrel, rather than with the pug, Seurat attributed the more democratic and serious position to himself.

Recapitulating this role of cat and dog as artist's surrogate and companion are two of Paul Cézanne's most ambitious compositions, one from his youth, the other from his late work. *A Modern Olympia* (fig. 41) of 1873 shows a self-

Paul Cézanne, *A Modern Olympia* (detail of fig. 41).

portrait of the artist dressed as a dandy contemplating a reclining nude in a luxurious interior. He is accompanied by a curious and caricatured black animal whose form is cat-like but whose red collar indicates a dog.[50] As the latter, the little beast recalls the cuddly canine playthings of young ladies in eighteenth-century erotic paintings (fig. 42). There, they embodied unleashed sexuality, a far cry from the fidelity symbolism of earlier times.[51] Rather than staring at the viewer, as do both pet and prostitute in Manet's *Olympia*, both viewer and animal in Cézanne's picture are rapt before the nude.

Interpretations of this scene vary widely, but all of them recognize Cézanne's attempt as a young painter to define his identity and independence from the powerful influence of Manet.[52] In place of the staged realism of Manet's

42 Jean-Honoré Fragonard, *The Ring Biscuit: Young Girl Playing with a Dog on Her Bed*, *c.* 1775, Bayerische Staats-gemäldesammlungen, Alte Pinakothek, Munich.

Olympia, with its overt symbolism of the cat, Cézanne created a more ostenta-tiously personal art of self-conscious anxiety and desire.[53] The animal's prob-lematic identity is paralleled by confusion over whether it is the woman's companion or the artist's. Unresolved, such ambiguities inform the painting with uncertainties that were undercurrents to the artist's own conflicted aims and youthful appetites. Would he pursue the erotic subjects of his early work or follow more naturalist impulses, symbolized in the painting by still-life and the florid bouquet to the right?[54] Would he do further battle on Manet's terrain, engaging the art of the past and its symbolic strategies, or follow his as yet lesser-known friends, men like Monet and especially the landscapist Camille Pissarro, with whom he had been working for the past few years?

Answers to these questions can be discovered in Cézanne's return to some of these concerns in his late work, including, after many years absence, the role of the dog. For there is a canine presence prominent in the foreground of a composition which at the culmination of his career summarized Cézanne's highest ambitions. That is the *Large Bathers* (fig. 43), on which the artist worked for several years until his death. This monumental work brings together the genre of the nude and the landscape – the latter Cézanne's primary preoccupation since the 1870s. It evokes metaphorically the age-old theme of man and nature.[55] Is the dog a mere pictorial device, filling a gap and animating an area like clouds in the sky? Is it a reminiscence of classical art, perhaps the attribute of the goddess of the hunt, Diana, who might be echoed among Cézanne's nudes? Or is it simply a natural presence, accompanying the picnic items also displayed in Cézanne's foreground?[56] Surely the answer must be all of the above and more.

43 Paul Cézanne, *Large Bathers*, 1895–1906, Barnes Foundation, Merion, Pennsylvania.

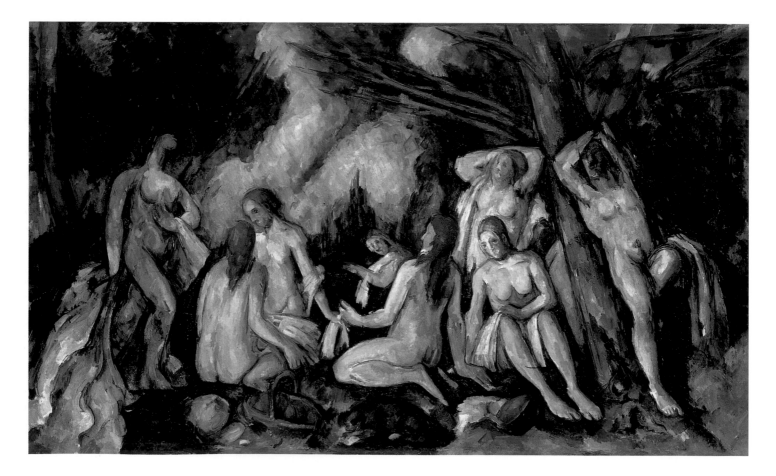

For in recalling the puppy excitement of his early *Modern Olympia*, Cézanne now shows desire domesticated, fulfilled through an effective fusion of the natural and the ideal, of modernity and tradition. Finally recognized and admired by art dealers and younger artists after a long period of obscurity, Cézanne could enjoy a degree of satisfaction and tranquility.

It would take a long essay on the art of Cézanne to elaborate on such claims, derived as they are from the lowly detail of a pup or two within Cézanne's overall complexity. But in so far as, through its earlier association with the artist, the dog represents the masculine element in paintings primarily of women, it cannot help evoking the animal dreams of the artist's youth. Contrasting with its former position, however, this recumbent canine fits harmoniously within its setting, rather than gazing voyeuristically from outside. In a composition of artistic maturity, Cézanne's ideal is now inclusive. The pet lies contentedly at the feet of its human keepers; indeed, in another version of the *Large Bathers* (National Gallery, London), a woman's arm rests reassuringly upon it.[57] As if in a return to the symbolism of fidelity (though that alone would be too limiting), this seemingly breedless generalization, like his classicized human companions, has come a long way from the yappy lapper of 1873. Cézanne thus transcended the artist-companion theme that both he and his predecessors once practiced far more literally. Yet the dog's unexpected reappearance nonetheless echoes that tradition in which modern painters defined their aims in the company of pets. In so doing the dog stands as a reminder that, to the very last, Cézanne maintained a commitment to and nostalgia for the ambitions of his youth and to his proud claims for a distinct if now over-arching artistic identity. In addition, it affirms that in the merest fragment of an artwork may be contained the kernel of the grandest whole.

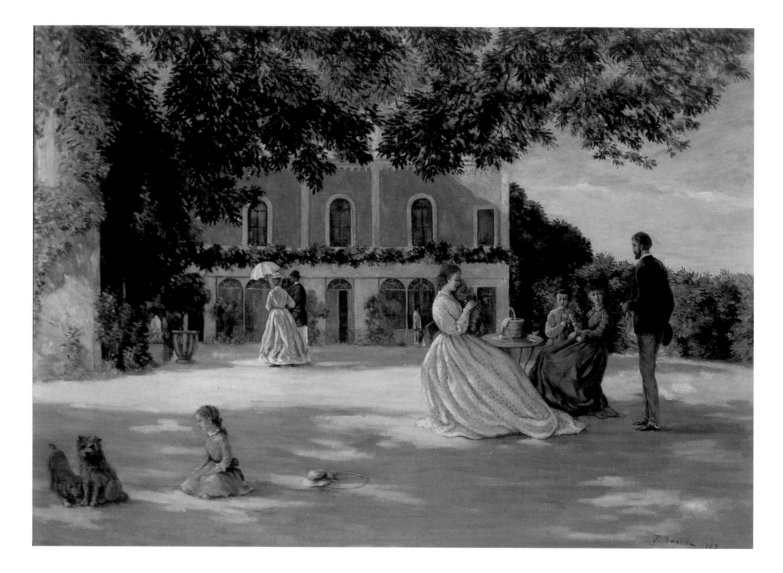

44 Frédéric Bazille, *Family Reunion on the Terrace at Méric*, 1867, Musée du Petit-Palais, Geneva.

3

Gone to the Dog's House

"*I*n the beginning, God created man. Finding him weak, he gave him the dog. He charged the dog to see, hear, smell, and run for man." These words are from *L'Esprit des bêtes* by Alphonse Toussenel.[1] He should have added, to provide friendship. The spread of pet-keeping to the middle classes and its association with emotional wholesomeness is a modern phenomenon. I have already mentioned that as signs of luxury and middle-class comfort, pets accompanied upward mobility. A more subtle explanation would add that as families are pulled apart and community roots wither, domestic animals become vehicles for emotional relationships. Their rise parallels human loneliness and loss; their popularity reflects nostalgia for intimacy and companionship. With their complete dependence and undying love, pets compensate for estranged or absent people. In Daumier's *Journée du célibataire* print set, described in chapter 1, they form a surrogate family. Nowadays, therapy using pets is increasingly popular.

In shifting the balance away from animals as pure symbols, the Impressionists regained them as members of the household. They especially present dogs as honest beings who are sometimes loved like children, as well as by children. In a picture of his family gathered on the terrace of their country house, the early Impressionist Frédéric Bazille (killed in 1870 during the Franco-Prussian War) divided the world of the child from that of adults (fig. 44). The little girl in the left foreground watches the dogs, as if hoping they will play with her. The two youngsters in Courbet's *Studio of the Painter* (fig. 11) allude to the unspoiled vision of children, whose innocence, paralleling the freedom of the white cat, the painter introduced as an antidote to academic conventions.[2] Baudelaire claimed that artistic genius was "nothing more nor less than childhood recovered at will."[3] The association between children and animals, though a fact of everyday family life, can also be understood as references to honesty and freedom, traits that modern artists found deeply attractive. Compared with human characters in paintings, dog personalities could be yardsticks for human behavior.

* * *

Though better known for thoroughbred racehorses than for hounds, Edgar Degas painted dogs in a number of important compositions. The first is his early masterpiece, the group portrait of his Italian aunt and cousins, *The Bellelli Family* (fig. 45).[4] In discussions of this complex image, the dog is rarely mentioned. A black toy-sized animal like a poodle or a terrier, it exits the space at the lower right, its head already outside the frame.[5] With this cruel decapitation, Degas created a range of possibilities. As a pictorial device, the animal implies extension of the painted scene beyond the frame. So the image Degas represented seems like a fragment cut from a larger world. The tactic has a double consequence. First, it enhances the picture's effectiveness as an illusion of reality. But second, it also calls attention to the artist's incisive, I would say *surgical*, pictorial composition – a characteristic particularly associated with Degas. His strategy of framing evokes photography, a technology believed to produce objective records of reality. Through it, Degas implied that his vision was scrupulously true. He sacrificed the dog to do it.

My use of the term "surgical" is meant to evoke the "scientific" method that had become a powerful influence in French culture. For example, the novelist Emile Zola used the term to describe his Naturalist novels. In a preface to his murder story *Thérèse Racquin* (1867), he compared his way of representing his subjects – an adulterous woman and her lover plotting to murder her husband – to the scientific analysis performed by surgeons in dissections.[6] At this time in history, medical science provided one of the most powerful models for objective inquiry. Zola and Degas shared attitudes exemplified by leaders such as Claude Bernard, Charles Darwin, and the pre-Freudian psychologist Dr. Henri Charcot. Charcot's public presentations of female hysterics at his lectures would now be considered cruel. Bernard, as mentioned above, was known for experiments on live animals, for which he was scolded by anti-vivisectionists. Degas's cropping of the Bellelli pet echoes this ruthlessness.

The innocent pup's withdrawal from the scene staged by the artist in his aunt's living-room comments devastatingly on a domestic psycho-drama. It is therefore much more than just an element of pictorial realism. Degas's subtle arrangement of figures in a shallow space, divided into sections by the shapes and positions of the apartment's furnishings, encourages the viewer to read a story from left to right. The artist's aunt Laura is dressed in black for her recently deceased father, Degas's grandfather, whose portrait is on the wall near her. Standing firmly with Aunt Laura is her older daughter, Giovanna. The younger

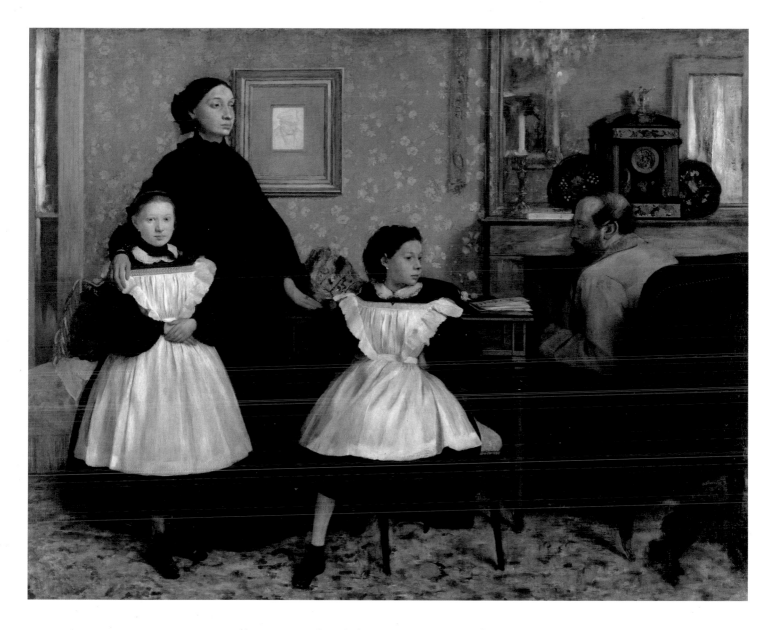

45 Edgar Degas, *The Bellelli Family*, 1858–60, Musée d'Orsay, Paris.

Giulia provides the link to Degas's uncle Giovanni Bellelli by looking tentatively toward him from her chair. The idle aristocrat, "without any occupation to make him less boring to himself" (to quote from one of Laura's letters),[7] is ensconced in a stuffed armchair, avoiding the stoic gaze of his domineering spouse by reading a newspaper. His position suggests the separateness of his world, reinforced by the mirror's illusion of a different space, as well as his

Edgar Degas, *The Bellelli Family* (detail of fig. 45).

reluctance to submit to the penetrating gaze of the artist, an ally of his wife. Concealing enormous effort and complex sensibilities under the appearance of objective observation, *The Bellelli Family* embodies the Degas clan's aristocratic code, where painful emotions are covered over by the requirements of social class and decorum. (The Degas family claimed noble status, although there is evidence it was fabricated by the painter's grandfather during the 1830s.[8])

The family dog leaves the room. He can't stand the hidden conflict. Counting on the belief that dogs react honestly to human situations, Degas used him to declare the Bellelli atmosphere tragic and unbearable. He is aware, also, of the dog's traditional reference to fidelity, here alluding to the demeaning sacrifices it requires. The oversize profile of Aunt Laura's body reveals that, despite her loveless marriage, she is pregnant with a third child. You have to wonder if Laura isn't mourning her freedom as well as her grandfather. Linda Nochlin has argued that this third pregnancy could be an instance of what would now be called marital rape.[9] So the unresolved frustration of wills is one in which the family pet cannot comfortably take sides. He is an instinctual being who surely loves each of his keepers equally. His impartiality becomes a moral foil for the opposing and partisan attitudes Degas has carefully, if joylessly, recorded.

A second example of Degas's use of a canine character in a tragic story is *The Daughter of Jephthah* (fig. 46), a painting he began, though never completed, at about the time of the Bellelli portrait. In the foreground, there is a strange conundrum, an odd unfinished dog-like form. The figures and relationships are derived from the story of Jephthah in the book of Judges.[10] Jephthah was the son of a harlot but a devout man, a valiant warrior with a band of followers. He had been recalled from exile by the Israelites to fight the Ammonites, who had declared war. In order to guarantee his victory, he vowed to the Lord to sacrifice "whatsoever cometh forth of the doors of my house to meet me, when I return in peace from the children of Ammon." He returns home victorious, but the first to greet him is his only child. As promised, he sacrifices her to God. Here is another bleak family situation, a rare example of human sacrifice in early

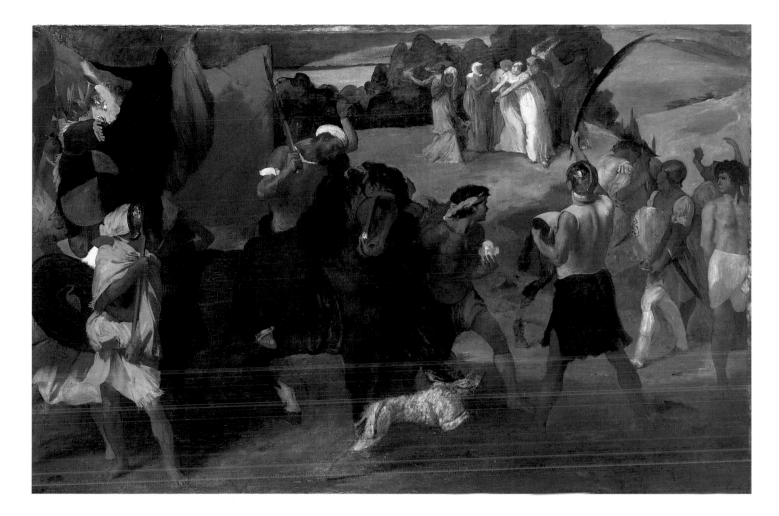

46 Edgar Degas, *The Daughter of Jephthah*, c. 1859–61, Smith College Museum of Art, Northampton, Massachusetts.

Jewish history. Unlike Isaac in the story of Abraham, divine intervention does not spare Jephthah's daughter. Given the opportunity by defeating enemies of the Israelites to consolidate his social status (made uncertain through circumstances of his birth), Jephthah guarantees his success through a rash promise.

Degas's painting shows the triumphant but motley band of warriors, including the prancing dog, returning with prisoners and spoils of war. The first soldiers in the procession greet the family, assembled proudly in the distance. Jephthah's daughter, dressed in the pure white of innocence and virginity, is the first to rush excitedly towards them. Jephthah's groom, anticipating the tragedy, tries to steer the leader's horse away – but too late. The hero himself, on horseback, lowers his head and turns his cheek, awkwardly attempting with his left

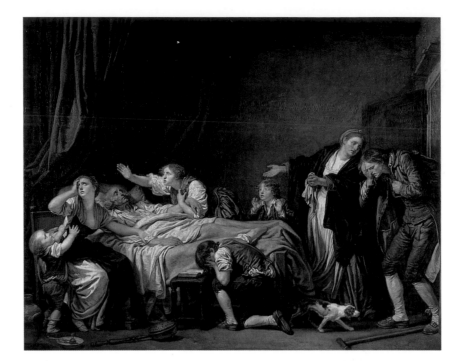

47 Jean-Baptiste
Greuze, *The Punished
Son*, 1765, Musée du
Louvre, Paris.

arm to shield his eyes from the sight of his beloved. With the right arm, he still brandishes an upraised sword, indicating the intention to fulfill his deadly vow. The dog, perhaps a greyhound or some other hunting breed, is again the barometer of the situation. Bounding forward with the joy of greeting, he expresses what should be the spirit of the moment. He stands in contrast to Jephthah's pain – to the cruel irony that makes his victory hollow and his ambitions worthless.

Both *The Bellelli Family* and *The Daughter of Jephthah* are family sagas through which the novelty and depth of Degas's pessimistic view of the human condition can be experienced. A comparison with an earlier artist's use of the family dog in a dramatic situation will clarify this point. In 1777, nearly a century earlier, the celebrated painter of domestic scenes Jean-Baptiste Greuze exhibited a pair of paintings that functioned as a kind of two-act morality play. In the first, *The Father's Curse*, Greuze showed the eldest son of a poor couple taking leave of home to seek his fortune with a sneering army recruiter. The father curses the foolish youth, who should stay home to support his four frailer siblings. They plead with him not to abandon the family hearth. In the second picture, *The Punished Son* (fig. 47), the wayward and now wounded son returns home leaning on a crutch. He drops the crutch to cover his face on discovering that his father has passed away just a few moments before. His brothers and

sisters surround the deathbed, mourning, while their mother, who opened the door, shows the situation to her shamed and grief-stricken eldest son. In this scene, the family dog, absent from the first painting, is given a moralizing role.[11] This mixed-breed mutt may bear no pedigree, but he definitely knows right from wrong. His loyalty is to the family, and he snaps angrily at the prodigal son for his errant ways, representing the judgment of artist and society upon him. Like Greuze's dog, Degas's pets respond morally to human situations. But Greuze's strategy is unrealistic, for isn't a dog's love unconditional? Shouldn't it welcome the son, regardless of the situation? Greuze was simplistic, whereas Degas recognized that some situations are just too complicated for a bark.

Degas is said to have disliked dogs as a cranky old man, but when he was younger, two of his closest friends kept them as intimate family members.[12] In two paintings where the artist chose to represent them, the animals' presence is crucial to understanding their masters' lives. Both pictures again tell stories, though far less dramatic ones than those just described. The first is the exquisite *A Carriage at the Races* (fig. 48), a portrait of the family of Degas's boyhood friend Paul Valpinçon. In it, Degas used the slicing effects of his edges so boldly that many viewers overlook the charming scene within the carriage. In the summer of 1869, like many Parisians, Degas traveled to Normandy, where he stayed with the Valpinçons on their country estate. *A Carriage at the Races* records an outing to the nearby racecourse at Argentan.[13] Tents, corrals, riders, and some spectators are seen across the field in the distance. Against this background, the baby Henri Valpinçon dozes off in the carriage, leaving his wet-nurse's breast dangling. His attentive mother checks the situation; pet bulldog and father look on from their proud perch on the driver's seat. Degas's observations of social class are astute: the intimacy of the mother, child, and nurse shows how a bourgeois family's service staff is taken for granted. The nurse's breast exposed in broad daylight is no impropriety; among women of her class, it is a function of utility, not sex. The father's dominant position and formal dress signify his public status, while the women and children remain in protected comfort.

The French bulldog, seen from behind, is an intermediary between these public and private worlds. Bulldogs were still relatively rare in France, where they were considered dangerous fighting animals; they were far more popular in England.[14] Horse racing, too, had entered French elite culture from England. So the bulldog further displays Valpinçon's status and trendy taste. Its position in the picture also parallels the father's, with important differences. It faces the center of the scene and appears absorbed in watching the baby and nurse. By

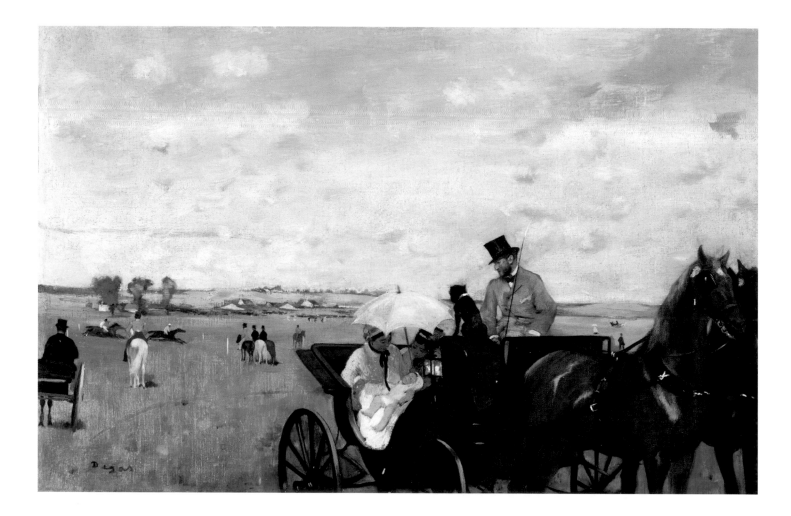

contrast, Valpinçon's posture is more reserved, his expression somewhat self-conscious. He looks as if the maternal concerns of child-raising are new to him, outside his domain, and ever so slightly repugnant. He is separated from the others by the brown line of the whip with which he drives the horses. His authority, indicated by that instrument, gives him rule over lower orders and menial functions.

The dog's position on the high seat places him in solidarity with the husband. He, too, is an outsider. His white collar, which is on the one hand a sign of his domestication, actually humanizes him at the same time. Combined with his black coat, it echoes the contrast between the master's white formal shirt and his black tie and hat. It is as if the animal's subjugation to its keeper, normally the sign of an inferior species, also includes an opposite effect – bringing him into the family to be treated like an older child. Remember Daumier's litho-

graph (fig. 10), in which the newly licensed pet was welcomed into the family. You could say that here the dog watches with all the fascination of a sibling, one whose bond with the infant seems even greater than the father's, perhaps because it is based on more equality and unfettered emotion.

Degas's next painting of a dog-owning family was *Place de la Concorde: Viscount Ludovic Lepic and His Daughters* (fig. 49), a work rediscovered in the 1990s at the Hermitage Museum of Saint Petersburg.[15] There was no such thing as a true "snapshot" in his day, but Degas's photograph-like cutting-off of figures, in a layout very similar to that of *A Carriage at the Races*, does create an effect of instantaneity. The viscount – a painter, watercolorist, and printmaker with whom Degas collaborated and brought into the Impressionist circle – seems to wander aimlessly across the most splendid public space of Paris. The glorious, tree-lined Avenue des Champs-Elysées is behind the viewer; the garden of the

49 Edgar Degas, *Place de la Concorde: Vicomte Ludovic Lepic and His Daughters*, 1875, State Hermitage Museum, Saint Petersburg (formerly the Gerstenberg Collection, Berlin).

Tuileries provides the painting's backdrop, with the beginning of the posh arcades in the Rue de Rivoli to its left. The slicing effect at the left-hand edge suggests a random, glancing view. Depriving his principal figures of apparent footing by amputating them at the knees makes them seem to float across the surface against which they are flattened, appearing nearly weightless. Lepic's body language indicates a leisurely pace, with his right arm behind his back and his left arm squeezing his umbrella. He bites jauntily on his cigar. The figure to the left is a bystander momentarily distracted by the family. Only the alert greyhound notices him.[16]

Lepic's sleek pet was named Albrecht, after Albrecht Dürer, whose fine prints and drawings, including those of animals, Lepic certainly admired. A photo-

50 J. Sauvager, Photograph of Vicomte Lepic's dog Albrecht, n.d.,
private collection.

graph (fig. 50) shows Albrecht in a position similar to that in the painting.[17]
Although there is no absolute proof, it is probable that Degas used it. Albrecht
is not a cuddly animal, neither a lap dog like those possessed by mistresses
and children, nor a pillar of family life like Porthos in Renoir's portrait of the
Charpentiers (fig. 2). Although greyhounds are extremely affectionate and intel-
ligent when raised in homes, in the nineteenth century they were associated
with the hunt, for which their speed was highly valued. Their heritage was there-
fore aristocratic. In fact, many believed that the human hierarchy of social class
was paralleled by dogs. A wood engraving made by Grandville in 1843 shows
this point in an amusing way (fig. 51). In 1875, the same year as Degas's *Place*

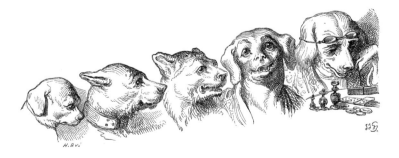

51 J.-J. Grandville,
The Evolution of Dogs,
wood engraving from
Magasin pittoresque, 1843.

67

52 Gustave Courbet, *The Greyhounds of the Comte de Choiseul*, 1866,
The Saint Louis Art Museum, Missouri.

de la Concorde, a popular journal proclaimed: "The upper aristocracy is per-
fectly represented by the greyhound clan, which is almost as rarified as that of
the true nobility."[18] A list of coats of arms in Larousse's encyclopedia shows
sixty-three noble families with greyhounds, compared with eighteen for all other
breeds.[19]

Greyhounds were the subject of one of the relatively rare dog portraits
(without any people) made by an avant-garde artist during this period,

Courbet's *Greyhounds of the Comte de Choiseul* (fig. 52). Comparing it with the Degas is revealing. Courbet had been doing seascapes along the Normandy coast, accompanied by his friend Monet. (Here is the explanation for Monet's change of Courbet's dog to a greyhound in *Le Déjeuner sur l'herbe*, fig. 26.) Courbet was proud to be a guest at the count's summer villa in the chic resort of Deauville, where his host pursued an interest in the latest art by collecting and by entertaining young painters. Yet as Robert Rosenblum has observed, the brown dog's oddly foreshortened rump is far more common than noble.[20] Courbet was attuned to the dogs' inner life, too. The darker one focuses on something off to the right, while the other cocks its ear in the same direction. Courbet's intense blue sky and roughly painted sand use the pictorial vocabulary out of which Impressionism would grow. His handling of paint gives a textural quality to the fur that enhances one's sense of its physicality. He used a simplified backdrop to heighten the greyhounds' scale, and the viewpoint is placed at their level. Although Courbet may have enjoyed the attention of his aristocratic patron, then, his attitude toward the dogs shows no response to the status of their owner. On the contrary, he brought to them a warmth and understanding that suggests affection for them on their lower animal terms.

In English the term greyhound designates a family of hounds. In French, the term is *levrier* (hare hunter), of which the English greyhound is a type. Lepic was a dog breeder and certainly understood such distinctions. Breeds were far less defined and more open to experiment in his day than now, having become regulated by official kennel clubs. Lepic indeed identified so much with dogs that they were an important element of his artistic imagery, as in his etching of the fighting bulldog *Jupiter* (fig. 53).[21] He considered this print worthy enough to be exhibited in 1874 at the first Impressionist exhibition. Thus, Albrecht stood for a gentleman's hobbies – dog breeding and the making of art. He was a sign of Lepic's status linked to ancient hereditary privilege. He is far less likely to have

53 Ludovic-Napoléon Lepic, *Jupiter, Portrait of a Dog*, etching (after a painting by Louis Jadin), 1874, Département des Estampes et des Photographies, Bibliothèque Nationale, Paris.

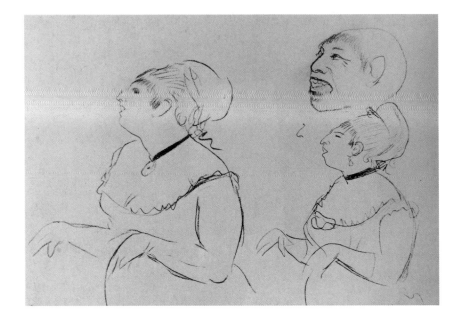

54 Edgar Degas, page of a notebook with a sketch for *The Song of the Dog*, c. 1877, private collection.

been the playmate of Lepic's daughters than the master's personal pet. Perhaps it was the dog who was minding the children – the viscount seems lost in his thoughts, oblivious to his charges. As far as he is concerned, all three may as well belong to the same order of being, given that he was a nurturer of animal as well as human pedigrees. (Lepic was proud of his family's Napoleonic connections, naming his youngest daughter Eylau, after one of the emperor's most famous military victories.[22]) Degas shared similar snooty upper-class values.

In *Place de la Concorde*, Degas connected the greyhound and the daughters in visual terms, especially the girl to the left. This observation can be explored by comparing the similarities between animals and humans elsewhere in his work.[23] It is widely known that in many of his ballerina images, Degas made

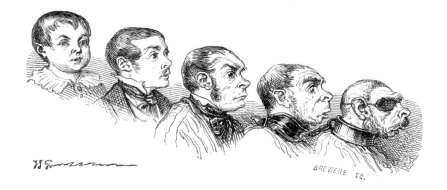

55 J.-J. Grandville, *Man Descending towards the Brute*, wood engraving from *Magasin pittoresque*, 1843.

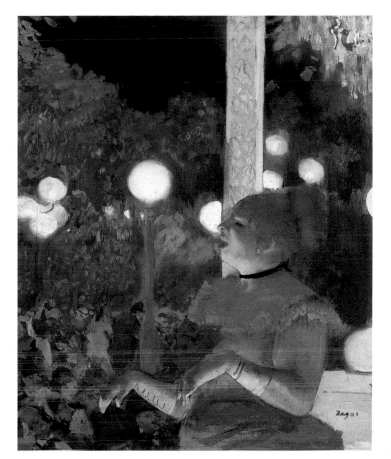

56 Edgar Degas, *The Song of the Dog*, c. 1878, private collection.

young women unattractive, sometimes even animal-like. (The entertainment profession was not considered respectable in his day.) A sheet of studies (fig. 54) for his superb *Song of the Dog* (fig. 56) represents a popular cabaret singer with a progressively ape-like physiognomy. In the painting, she makes a dog-like gesture.[24] Such strategies have led to debates on Degas's attitudes toward women.[25] He himself confessed he may have looked on women too much as animals.[26] In his pictures of animals, it is uncertain whether he shared Courbet's or Lepic's warmth, preferring to use them as tools to illuminate the characters of their human keepers. Following the scientific interests of his day, Degas believed character could be read in facial features (see chapter 1). His studies for *Song of the Dog* resemble juxtapositions between men and animals found in the scientific literature, as in Darwin's book on emotional expression (fig. 8). If man descended from the apes, then lower classes and less respectable humans would present semi-ape-like features, as in a print by Grandville of 1843 (fig. 55).[27]

As a man who never married and took his pleasure in brothels, Degas probably had a limited knowledge of children, liking them perhaps even less than dogs. To present-day eyes, the comparison between Valpinçon and his bulldog in *A Carriage at the Races* seems unflattering to Valpinçon because of his detachment from the family. But within upper-class social conventions, Degas would have found his friend's attitude appropriate. Even so, whether *Place de la Concorde* actually reveals distaste for the Lepic children is open to question. On one hand, the artist may have felt they were barely more developed than an intelligent dog. But on the other, the effect of the painting could be explained as a form of realism which had to be brutal in order to prove its authenticity. With a friend like Lepic, Degas could render such a vision honestly. Lepic's love for dogs made Degas's comparisons less offensive than may too easily be assumed.

Who Had a Bone to Pick?

In 1869, Renoir and Monet painted side by side at La Grenouillère, a bathing spot along the Seine at Bougival, near Paris. Outdoor bathing was a recent health fad, and La Grenouillère was so popular that even Napoleon III and his wife visited it that year.[28] Renoir's (fig. 58) and Monet's (fig. 59) versions of nearly identical scenes are often juxtaposed in order to show shared aspects of Impressionism as painting done on the spot, outdoors in natural light, freely executed in a sketch-like style. Sometimes the analysis goes farther, to reveal differences between the friends, despite many beliefs and practices in common. Monet's broader brushstrokes suggest an abstract vision linked to his over-riding concern for form and light. Renoir's crisper rendering with his more pointed brush implies his interest in precise descriptions of figures and their social interactions. Ostensibly observing the same scene, Renoir included several dogs in his paintings of La Grenouillère, while Monet included hardly any; it is curious that this has not been noted before.

On the round wooden float in the center of the Renoir (fig. 58), a white fox-terrier-like dog lies snoozing while fashionable young couples chatter. In Renoir's painting of the riverbank (fig. 60), whose location is contiguous on the left with the other painting, two dogs are featured in the foreground. One lounges on its side while watching the other, to the left, which curiously sniffs the ground. A second Monet (fig. 57), located to the left of his other view, concentrates more on rowing-boats than on the shore and shows no corresponding

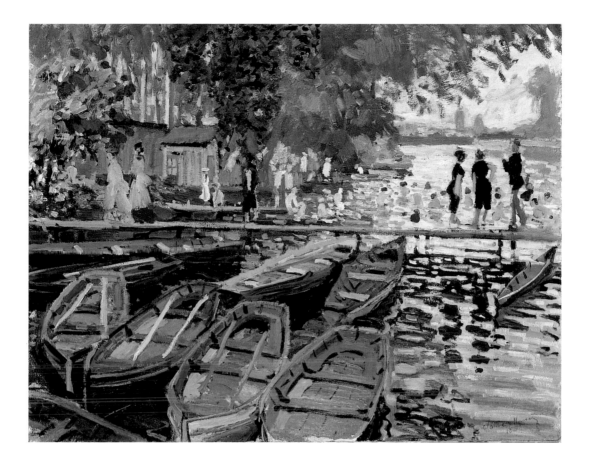

57 Claude Monet, *La Grenouillère*, 1869, National Gallery, London

canine. Renoir's love of illustrative detail is confirmed by the resemblance of his scene to a wood engraving by Jules Peloq in an issue of the *Journal Amusant* of 1873 (fig. 61). Here, the humorous caption reads: "An Eden where animals and people coexist in gentle confraternity; cordial exchange of fleas (by individuals of the canine race)." There are three dogs of distinctly different breed in Peloq's foreground. As many as nine more are on the float or the walkway. Fortunately, none is in the water. There were limits to the brotherhood of dogs and man!

Unlike Monet, Renoir is not especially known for landscapes, and among those he made in the 1860s, well-populated urban or suburban scenes are prominent. Before reading on, it might be a challenge to see how many dogs are present in the *Skaters in the Bois de Boulogne* (fig. 62) and the *Pont des Arts* (fig. 63). Take a moment to search for them. In the first, a rare and beautiful winter scene, there is a dog to the right of center. It is a tiny figure but prominent,

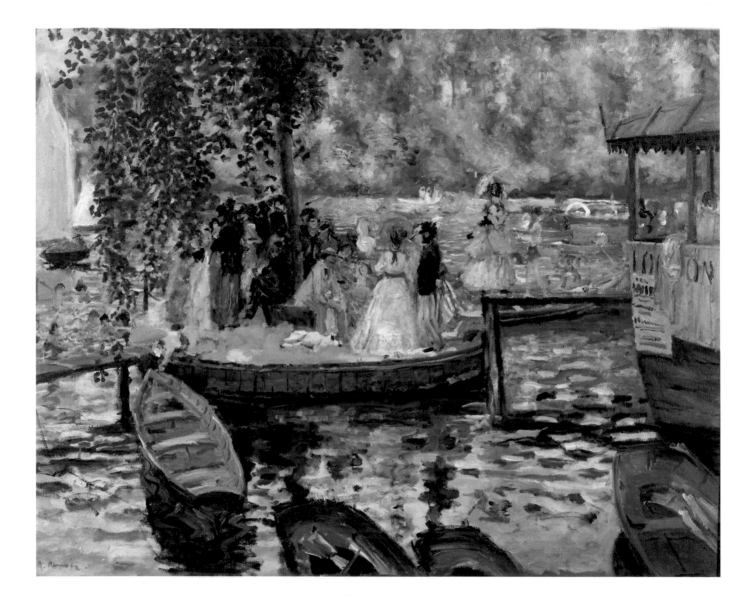

58 Pierre-Auguste Renoir, *La Grenouillère*, 1869, Nationalmuseum, Stockholm.

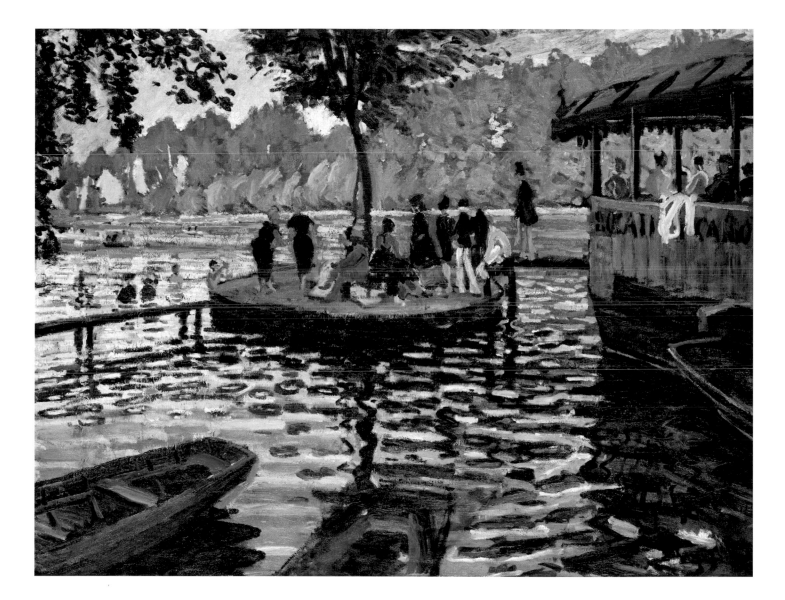

59 Claude Monet, *La Grenouillère*, 1869, The Metropolitan Museum of Art, H. O. Havemeyer Collection, Bequest of Mrs. H. O. Havemeyer, 1929. (29.100.112).

following page Pierre-Auguste Renoir, *La Grenouillère* (detail of fig. 58).

page 77 Claude Monet, *La Grenouillère* (detail of fig. 59).

60 Pierre-Auguste Renoir, *La Grenouillère*, 1869, Pushkin Museum, Moscow.

standing alone surrounded by bright snow, encircled by figures and shadow. It is hard to know whether it is in the company of the people it faces, the woman dressed with red trim directly above it, or the man pushing a lady on a sled just behind her. But its solitude does highlight by way of contrast the feeling of human socialization present elsewhere.

The *Pont des Arts* is at the heart of artistic and intellectual Paris. Renoir is looking down the left bank on the Quai Malaquais toward the Institut de France, with its elegant seventeenth-century dome, to the right. The Pont des Arts was a cast-iron pedestrian bridge which linked the Musée du Louvre on the right bank of the Seine to the left bank, at a spot across from the Ecole des Beaux-Arts. (Both landmarks are outside this picture's field of vision.) Fashionably dressed tourists line up to take the open air on excursion boats that cruise the Seine. Two terrier-like dogs playing in the center middleground may reflect the location nearby of Paris's most exclusive bathing place for dogs.[29] They also enhance a sense of freedom which contrasts with the presence of a less pros-

Un Eden où bêtes et gens se meuvent dans une douce confraternité ; échange cordial de puces (de la part des individus de la race canine).

61 Jules Peloq, *La Grenouillère*, wood engraving from *Journal amusant*, no. 991, 1873.

perous mother and daughter, as well as idle boys to the far left, who may have been begging. This scene may again be compared with a painting by Monet, located exactly across river, the *Quai du Louvre* (fig. 64). Whereas Renoir's view excluded famous landmarks, Monet's more panoramic scene features the statue of Henri IV on the Pont-Neuf and the cupola of the Pantheon at its center. Even so, in its lower register there are many figures, with plenty of human activity. Yet not a single dog can be seen.[30]

When Monet began painting as a young man on the Normandy beaches, he much admired the local painter Eugène Boudin, claiming Boudin had opened

62 Pierre-Auguste Renoir, *Skaters in the Bois de Boulogne*, 1868, private collection.

facing page Pierre-Auguste Renoir, *Pont des Arts* (detail of fig. 63).

63 Pierre-Auguste Renoir, *Pont des Arts*, 1867, Norton Simon Museum, Pasadena.

his eyes to nature. Yet Boudin's scenes of vacationers at the seaside are teeming with dogs, as in *Empress Eugénie and Her Suite at Trouville* (fig. 65), where there are three in the foreground, each of a different breed. The empress is walking her bichon, possibly a Maltese; the other dogs, owners not apparent, seem to be more common types. Dogs were certainly a part of the pleasing bourgeois life that both Monet and Renoir depicted. So before one concludes that Monet had a bone to pick with pets, or assumes that his works can be judged by animals alone, one should consider the role of Renoir's dogs and why Monet left them out, even when his mentor Boudin willingly included them.

Renoir's dogs inject a note of playfulness and spontaneity into his pictures, thus creating associations with pleasure, particularly the pleasures of leisure and companionship. For Renoir, who may well have had an affection for pets that Monet lacked (but that itself is not the point), the inclusion of pets helps render

64 Claude Monet, *Quai du Louvre*, 1867, Gemeentemuseum, The Hague.

his scenes familiar and anecdotal, even comforting. In most of his pictures
described so far, friendship is an important theme – whether among artists,
couples weekending in the country, or families touring Paris. Compare Monet's
more psychologically distanced and visually abstracted compositions, an effect
achieved through choice of distant viewpoint, concentration on objects rather
than people, or suppression of detail in favor of effects of light. Returning to
Monet's *La Grenouillère*, one may note a blotch of whitish paint on his repre-
sentation of the float in approximately the place where a dog might be found.
If it can be supposed that this marking corresponds to a dog, then I would argue
that it obliterates rather than represents a species, transforming it into a color
notation where it is deprived of the anecdotal charm associated with pets. Yet
both artists present images based on reality – Monet through seemingly dispas-
sionate observation, Renoir through attention to particulars. For Monet, the

65 Eugène Boudin, *Empress Eugénie and Her Suite at Trouville*, 1863, Burrell Collection, Glasgow.

pleasure is primarily visual and private. Sociability is what the gregarious Renoir enjoys.

It is not that Renoir calculated the inclusion of pets in order to produce that effect or that their exclusion would destroy it. For Renoir, pet-keeping was simply a part of modern life which deserved to be recorded, no more yet no less than other aspects. The same is truc for his inclusion of children. In Monet's *Quai du Louvre*, children are rare and older than in Renoir's *Pont-Neuf* (fig. 66), which is seen from slightly farther up the same embankment of the Louvre. In this last urban landscape by Renoir, there are three dogs (try to find the white poodle and the little black dog in the foreground, and the third pooch on the riverbank); there are also at least three young children, one of whom, to the right, is staring at the little pup nearby. For Monet, who painted exactly the same place without dogs (*c.* 1872, Dallas Museum of Art), these charming aspects of modern life were superfluous, as though they distracted from the purer aesthetic pleasures of vision that his equally brilliant but very different pictures produce. You could say that for Monet, the social was just a vehicle for the visual, whereas for Renoir, painting was a way of connecting with others.

In a number of important paintings by Renoir, pet dogs are prominent, but there is room to discuss only a few more. The earliest is *Bather with Griffon*

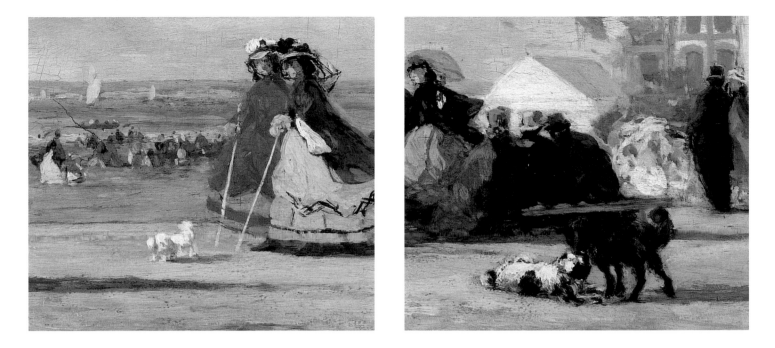

Eugène Boudin, *Empress Eugénie and Her Suite at Trouville* (details of fig. 65).

(fig. 68), a life-size painting which, like *The Inn of Mother Antony*, was directly inspired by Courbet. In this case, the inspiration was Courbet's controversial *The Young Ladies of the Banks of the Seine* (fig. 67), which shows two women of the demi-monde, possibly lesbians, lounging on the riverbank. The woman in Courbet's foreground has removed her dress in the summer heat and stretched out on it for a nap in her fancy undergarments. No woman of high social standing would condone such an appearance. And, in any case, why keep on her gloves? She and her companion have arrived by rowing-boat at a presumably secluded spot, but the man's hat in the boat implies they are not without company. The viewer's imagination easily completes the story. Could the voyeur be Courbet? By comparison, Renoir's woman – his mistress Lise Tréhot – ought at first glance to appear even more risquée, for she is nude. But her lovingly painted Belgian griffon terrier in the foreground introduces a note of domesticity, and there is no overt evidence of a male companion.

Scenes of female bathers have a long tradition in the history of art. Renoir's figure looks away and modestly covers herself in a gesture paraphrasing ancient statues of the chaste Venus. She is therefore more easily assimilated to images of ideal beauty than is Courbet's bizarre display of petticoats. In the Renoir, that ideal is located in the present through Lise's realistically ample body, her asso-

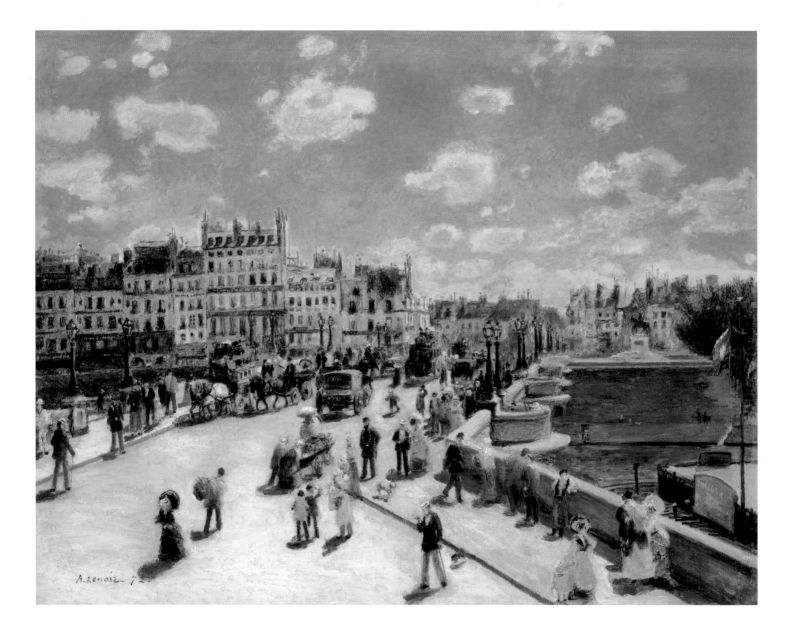

66 Pierre-Auguste Renoir, *Pont-Neuf*, 1872, National Gallery of Art, Washington, D.C., Ailsa Mellon Bruce Collection.

facing page Pierre-Auguste Renoir, *Pont-Neuf* (detail of fig. 66).

67 Gustave Courbet, *The Young Ladies of the Banks of the Seine*, 1856–57,
Musée du Petit-Palais, Paris.

ciation with the contemporary fashion for bathing, and her display of the latest style in clothing – striped dress and straw bonnet on the ground. It is a relatively domestic situation for liberal young lovers, as artists and their girlfriend-models tended to be. The clothed woman reclining in the background introduces a questionable note; but could she simply be a chaperon? The little dog helps to keep the scene idyllic and sincere. Imagine the different effect of a slinky cat!

One of the most famous pets in the history of art is Porthos, the Newfoundland belonging to the Charpentier family (fig. 70).[31] Black and white newfies were so popular with the English animal portraitist Edward Landseer that the type owned by the Charpentiers was known as a Landseer Newfoundland. According to Prévost's book on pets, the Newfoundland was

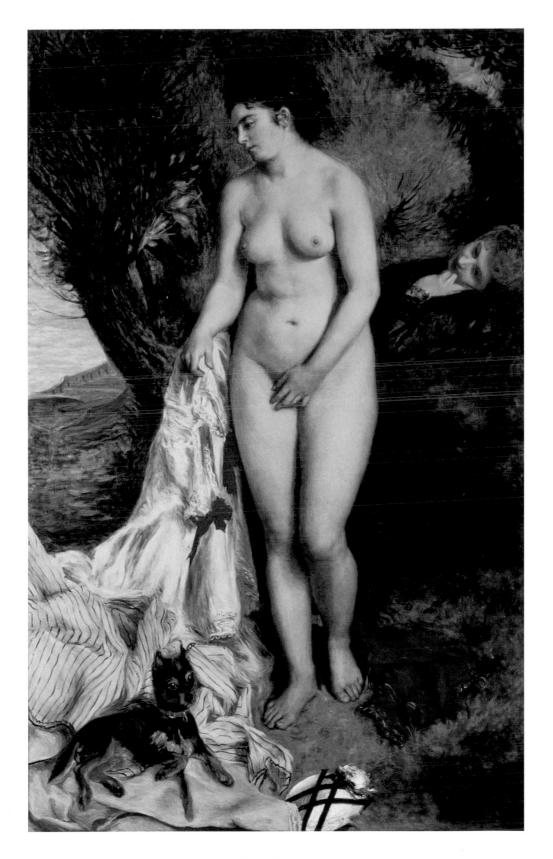

68 Pierre-Auguste Renoir, *Bather with Griffon*, 1870, Museu de Arte Moderna, São Paulo.

beloved for its "even disposition: such a good companion, such a faithful guardian."[32] In even the most supposedly scientific studies on animals, evidence of their character was anecdotal, and the same stories were repeated over and again. A charming tale from the book *L'Intelligence des animaux* (1869) involves a Newfoundland.[33] A heartless master apparently decided to get rid of his pet, so he thrust the dog off a small boat into the river to drown. When the dog kept treading water, the beastly man hit it with a stick, but he lost balance and fell into the current himself. Upon this, the faithful Newfoundland found strength to rescue both his owner and himself by dragging him to shore. They lived happily ever after, the master ashamed of his cruelty and now eternally grateful. What better illustration to the quotation that heads the story: "That which is the best in man, is the dog." A similar account is illustrated in Alfred Barbou's luxurious book on the dog, published in 1888 (fig. 69).[34]

Porthos's owner Georges Charpentier was an important publisher of Realism and Naturalism in literature: Flaubert and Zola were among his authors. Porthos was the gift of the niece of another writer, whose memoirs Charpentier had published.[35] He is named for the musketeer famous for generosity and strength in Alexandre Dumas's popular novel *The Three Musketeers* (1844). Of the trio, Porthos is traditionally said to be Dumas's favorite. With his wife, Marguerite, Charpentier was a notable art collector, and the couple regularly hosted artists and writers at their Thursday dinners. Of the Impressionists, Renoir was the one most frequently at their house – and the most devoted to portraiture, which depended on commissions he might solicit there. *Madame Charpentier and Her Children* was a vehicle through which Renoir had entered official art circles and gained respectability among connoisseurs otherwise hesitant to accept Impressionism. In 1878, he showed at the state-sponsored and academy-dominated Salon, abandoning the independent shows the Impressionists had been holding. Through Charpentier's influence, the portrait was hung to advantage at the Salon of 1879.

Renoir's image of Charpentier's family displays their modernity in several ways. Bamboo furniture, the Chinese rug, and Japanese screen reflect the couple's showy up-to-

69 Illustration of a Newfoundland rescuing a child, from Alfred Barbou, *Le Chien: Son Histoire, ses exploits, ses aventures*, Paris, 1888, p. 97.

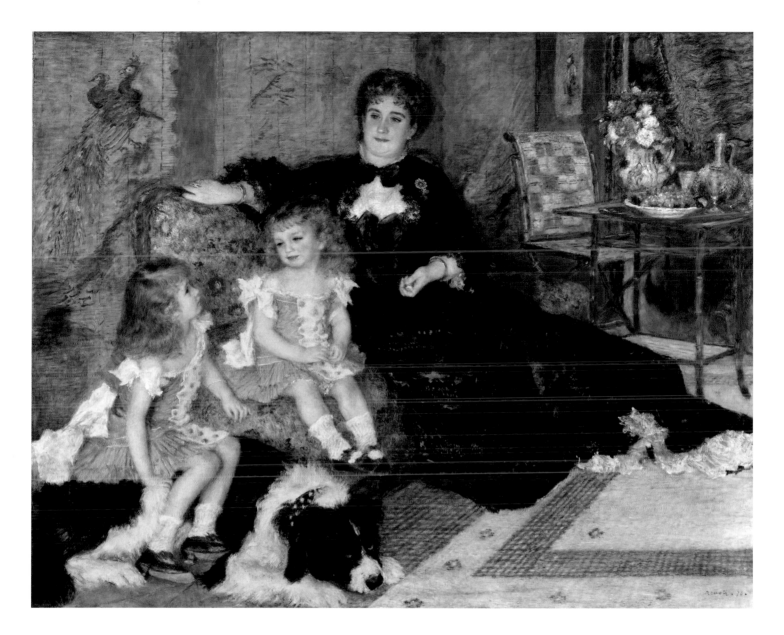

70 Pierre-Auguste Renoir, *Madame Charpentier and Her Children*, 1878, The Metropolitan Museum of Art, Catharine Lorillard Wolfe Collection, Wolfe Fund, 1907. (07.122).

date taste in interior decorating. Madame Charpentier is luxuriously dressed in a flowing gown from the fashion house of Worth, befitting a grand reception. Yet despite her wealth, Marguerite is represented less as a *grande dame* than as model mama with her pampered children – daughter Georgette, age six, to the left and son Paul, age three, next to her. (Paul is often mistaken for a girl, but at his age doting parents often dressed children of both sexes cutely alike.) Com-

71 Nineteenth-century French dog collar, Leeds Castle, Kent.

pleting the family circle is Porthos, sporting a thick, studded collar of a type popular in France (fig. 71). His gaze is both proud and careful as he supports Georgette on his sturdy yet comfortably plush back. The two of them were special pals, judging by a photograph taken of them in the country (fig. 72).

This setting represented a departure from conventional portraiture, which still imitated the aristocratic mode of stiff poses in front of draperies, gardens, or other status-enhancing props. By contrast, the Charpentiers project modernity through a display of committed domesticity, in which children have a presence in the household and the mother a direct role in rearing them. There is no wetnurse present in the picture; the Charpentiers aspired at least to the appearance of a "natural" family structure. Degas's painting of *The Bellelli Family* offers a revealing contrast. Unlike the stealthy exit of the Bellelli's toy-sized dog, Porthos is the rock and anchor of this domestic group. Although Monsieur Charpentier is not present, you might say that through his artistic patronage he identifies this image as his personal vision of ideal home life. The woman he encouraged to be his partner in all his non-commercial activities is the dominant presence in Renoir's scene. The family dog, whose black and white fur echoes the mother's elegant outfit, frames the children on the other side. He is a generous and reliable stand-in for the man of the house himself. With his size and physique, Porthos is not unlike those wise

72 Anonymous, Photograph of Georgette Charpentier and Porthos, *c.* 1879, private collection.

facing page Pierre-Auguste Renoir, *Madame Charpentier and Her Children* (detail of fig. 70).

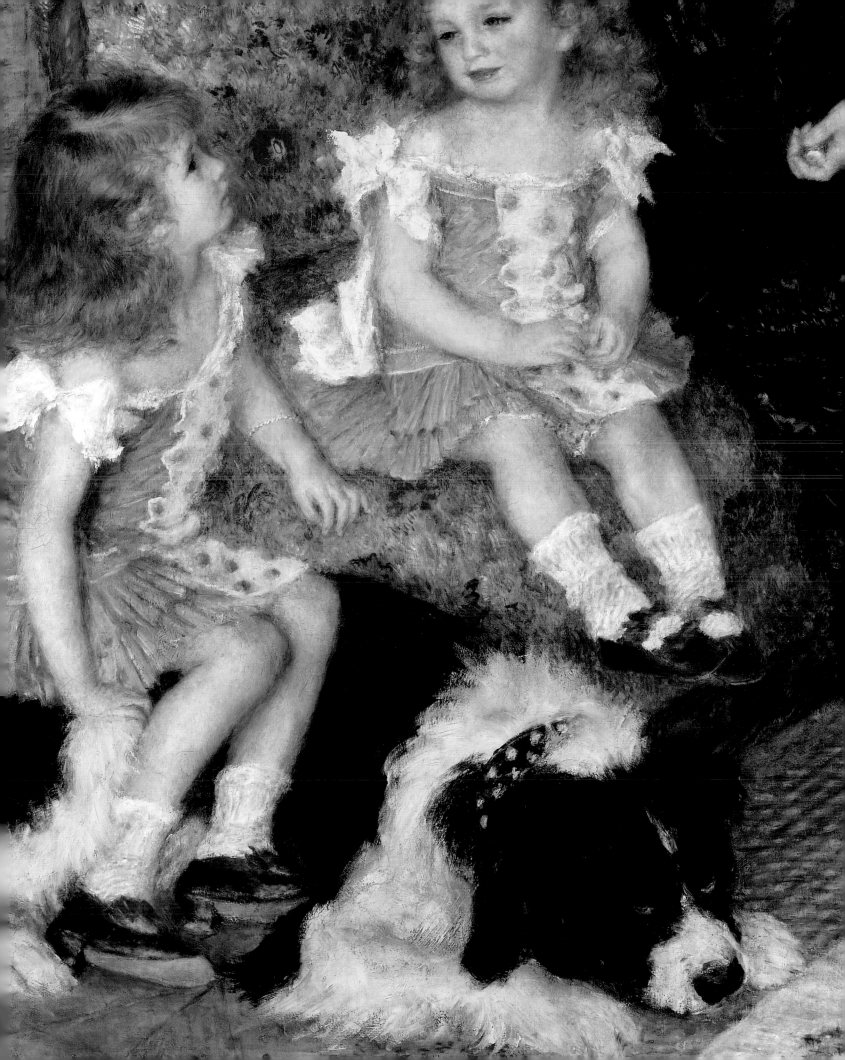

guardian lions of antiquity – as in the Lioness Gate of Mycenae on the island of Crete or at the entrance to the New York Public Library. In fact, Renoir has used his winter coat of fur (instead of the shorter summer cut in the photograph) to expand the viewer's impression of his scale and importance.

Evidence of pets in Renoir's own surroundings can be found in the *Luncheon of the Boating Party* (fig. 73), which he completed a few years after the Charpentier picture.[36] To the left of this group portrait on the terrace of the Restaurant Fournaise on the Seine at Chatou, Renoir's most recent mistress (and future wife) Aline Charigot plays with her long-haired terrier, possibly a Scotch or Yorkshire type. Identification of breeds in nineteenth-century paintings can only be approximate; the standardization that exists today was barely beginning at the time. Barbou devoted an entire chapter to Paris city dogs – meaning small indoor breeds – and illustrated the three most popular types: the griffon, the barbet, and the havanese (fig. 74). Aline's fits into this general category.

This part of the Seine was familiar territory for Renoir, whose parents lived nearby. The group includes friends and associates: from the two oarsmen – Alphonse Fournaise junior to the left and Gustave Caillebotte to the right – to the actress Ellen Andrée, speaking to Caillebotte, and Renoir's model Angèle, at the center, downing a glass of beer. Aline was fresh from the provinces, living in Paris as a dressmaker. Renoir was attracted to working-class girls; his own background was similar, his father having made a living as a tailor. In her profession, Aline would have understood the latest fashions. Renoir represented her with a fancifully decorated straw hat and a snappily trimmed dress showing off her narrow waist. Cuddling her doggy, Aline has all the innocence and charm Renoir sought in women, whose duty he felt was to be graceful and to whom he never credited any brains. How different from Madame Charpentier, and how different is the role of Aline's pet from Porthos – a mere plaything rather than family stalwart. Renoir's feathery painting of the soft fur and the tiny features of the terrier parallels his silky treatment of women as objects of desire and seduction. Aline and the dog are two of a kind, and Renoir's regard for her is not unlike hers for the petite pooch – an object for pleasure and possession.

* * *

73 Pierre-Auguste Renoir, *Luncheon of the Boating Party*, 1880–81, Phillips Collection, Washington, D.C.

Ladies and Their Lappers

Judging from Renoir's paintings of Lise Tréhot and Aline Charigot, it seems that lap dogs were often attributes of serious girlfriends. The association between ladies and their dogs was so established that it became the subject of lengthy discussion in a rare little book by Alfred Bonnardot, *Des Petits Chiens des dames* (1856).[37] Unlike a common prostitute on the prowl who would have no time for high-maintenance pets – the independent cat is therefore more appropriate

74 Illustrations of the griffon
(*left*), the barbet (*below left*), and
the havanese (*below right*) breeds,
from Alfred Barbou, *Le Chien: Son
Histoire, ses exploits, ses aventures,*
Paris, 1888, pp. 256, 258, 260.

– the mistress takes a fashionable dog as her companion once she is established.[38]
She has no children, at least not right away. (Aline bore Renoir his first son,
Pierre, in 1885, but the painter was not ready to marry until 1890.) Even so, she
enters a semi-bourgeois domestic status; the dog becomes her companion, even
the sign of her improved situation (no longer a working girl), while her lover –
sometimes married with lodgings elsewhere – is away.

When the mistress became a wife, as with Aline, lap dogs did not disappear.
In at least two paintings of her, Renoir included a pet. The first is *The Apple
Seller* (fig. 75), done the year after they married, in which Aline poses with a
young girl and boy, the latter probably their son Pierre.[39] As a woman selling
apples approaches, the little lapper leaps forward to investigate. The second is
a portrait of Madame Renoir, made approximately twenty years later (fig.
76).[40]Aline gained considerable weight after giving birth to her children, and
she was later diagnosed with diabetes. Here, she looks older than her fifty-odd
years, and her bulk is set off by little Bob, the new puppy, whom she cradles

facing page Pierre-Auguste Renoir, *Luncheon of the Boating Party* (detail of fig. 73).

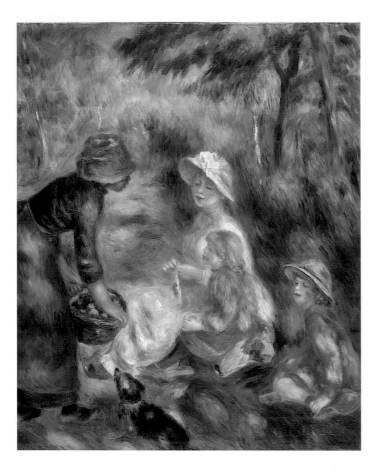

75 Pierre-Auguste Renoir, *The Apple Seller*, *c.* 1890–91,
Cleveland Museum of Art.

76 Pierre-Auguste Renoir, *Madame Renoir and Bob*, *c.* 1910,
Wadsworth Atheneum, Hartford, Connecticut.

maternally, literally on her lap. Pets were thus a part of Renoir's everyday life, and he treated them with fondness.

One could hardly find a greater contrast to Renoir's mistresses than *Little Girl in a Blue Armchair* (fig. 77) by the expatriate American Mary Cassatt. The sloping space and the tightly framed chair in the foreground combine with her ostensibly candid view of child and pet to suggest the "snapshot" quality of many pictures by Cassatt's close friend Degas. However, in contrast to Degas, Cassatt's sympathies with children were unmatched, and she achieved her greatest success as a painter of infants and their families. This is one of the few occasions on which she rendered a dog, but it is one which has made the picture one of her most endearing.

The little girl, about seven years old, is slumped in a soft armchair of what is presumably her family's comfortable sitting-room. No one is present except

for the pet, who can always be relied on to be a child's friend. In her matching plaid skirt, socks, and hair ribbon, the girl looks as if she has just returned from school. No wonder she's tired! In her fatigue and innocence, she has raised her skirt above her waist, revealing lacy petticoats. Even for a little miss, whose identity remains discreetly unknown, it is a highly informal pose. Almost a bit dejected, she gazes blankly away, in the direction of, but not directly at her pet. At first glance, it may seem the animal is painted as sleeping. But that is unlikely. As a rule, the smaller the dog, the more high-strung and sensitive it is likely to be to any nearby movement. So, despite its snoozing position, the tiny creature can open eyes wide in a nanosecond. Where its companion is oblivi-

77 Mary Cassatt, *Little Girl in a Blue Armchair*, 1878, National Gallery of Art, Washington, Collection of Mr. and Mrs. Paul Mellon.

Mary Cassatt, *Little Girl in a Blue Armchair* (detail of fig. 77).

78 Eugène Lambert, *Griffon Yorkshire*, etching,
from Gaspar Georges Pescow de Cherville,
Les Chiens et les chats d'Eugène Lambert, Paris, 1888, p. 131.

ous to an intruding gaze, her trusty lap dog faces guardedly outward, ready to respond with dyspeptic disputation.

The breed of Cassatt's painted pet is most likely one of the ever popular terriers, a dog Cassatt may actually have owned. In a letter to Lepic, Degas asked the viscount to send Cassatt a griffon or similar type.[41] This one looks like a Yorkshire griffon, as in an etching of 1888 by Eugène Lambert (fig. 78), a specialist in pets. Was this her own pup in the painting? Cassatt's amusing comparison between child and pet is of a different order from Degas's. The question of breeding is far less significant for Cassatt than her commentary on the beneficence of dogs and the innocence of childhood. In addition, Cassatt transformed a device that Degas used in many paintings to suggest realism – where a figure responds to the presence, even intrusion, of an outsider. One of the most famous historical examples of that device was Rembrandt's group portrait *The Syndics of the Clothmakers' Guild* (fig. 79). The figures look up at the viewer, as if their secret business meeting has been halted by an unexpected visitor. In focusing attention on a moment in time, Rembrandt was a precursor to the Impressionist sense of the instant. Such strategies were crucial to the realist effect of Impressionist paintings, in spite of loosely brushed, ostensibly unrealistic passages like Cassatt's rapidly sketched blue slipcovers.

79 Rembrandt van Rijn, *The Syndics of the Clothmakers' Guild*, 1662,
Rijksmuseum, Amsterdam.

The Impressionist picture closest to Cassatt's juxtaposition of child and pet is Manet's *The Railroad: Gare Saint-Lazare* (fig. 80).[42] A little girl, posed by the daughter of Manet's friend Alphonse Hirsch, gazes out over the sunken railroad yards from Hirsch's garden near Manet's studio. Manet's professional model, Victorine Meurent, recognizable as having posed for the prostitute Olympia, here plays the nursemaid. In her lap, Victorine cradles a slumbering puppy. Manet's use of the lap dog certainly contrasts with Cassatt's. In Manet's painting, Victorine looks out, perhaps echoing Olympia's gaze, although there is no cat. The little dog, whether it belongs to her or to her charge, implies the nanny's improved social status, although that doesn't mean she can't accept a rendezvous. In any case, in its utter obliviousness to the viewer, the animal is less symbolic than Olympia's cat and has far more in common with the child. Cassatt drew a contrast between her little girl's careless innocence and the dog's attentiveness. Manet's puppy also provides a contrast of sorts to Alphonse Hirsch's daughter. For while it simply snores away, the girl's indifference to the viewer behind her is the result of her fascination with the modern novelty of steam engines, puffing below. The dog's role as a contrasting feature is thus more subtle than that of Cassatt's terrier, precisely because it is so completely passive.

80　Edouard Manet, *The Railroad: Gare Saint-Lazare*, 1872–73, National Gallery of Art, Washington, Gift of Horace Havemeyer in memory of his mother, Louisine W. Havemeyer.

Cassatt's focus on her little girl's pet is key not only to the realistic situation in the sitting-room, but central to the work's links with revered art traditions – here recast in the charming terms of a child's daily home life. As a woman from a good Philadelphia family established as a Paris resident, Cassatt did not have the same access to public places such as cafés and music halls, nor the freedom to roam the landscape, as did her male counterparts. Unlike the woman in Caillebotte's *Pont de l'Europe* (fig. 33), she would not have strolled in a train station neighborhood without a chaperon. Yet paintings such as *Little Girl in a Blue Armchair* demonstrate Cassatt's commitment to the Impressionist principle of representing modern life, while lending legitimacy to her domestic version of it through ties to the Old Masters. There are few better examples of satisfying and lasting art made from the smallest of subjects.

It is surprising there are not more pets in the art of the women Impressionists, focused on domestic life and childhood as they mainly were. Cassatt's only other dogs sit conventionally on female laps (e.g. *Young Girl Sitting in a Window*, *c.* 1883, Corcoran Gallery, Washington, D.C.). In Berthe Morisot's oeuvre there are about half a dozen, mostly slight paintings, each showing a dog (in only one is there a cat) with a young model, a maid, or family member. One of the most accomplished of this group is *Young Woman with a Dog* (fig. 81), for which Morisot's niece, Paule Gobillard posed.[43] Although relatively standard in its composition, emphasizing tender affection, it is remarkable for Morisot's always superb and exuberant brushwork.

The same white terrier appears in Morisot's other representations of dogs, except for late in her career when she painted her daughter Julie Manet with her new pet greyhound (fig. 82).[44] (Morisot married Eugène Manet, the painter's brother, in 1874.) The dog, named Laertes after the character in Shakespeare's *Hamlet*, had been given to the family by the poet Stéphane Mallarmé, a close friend of the Manet brothers since the 1870s. Mallarmé earned his living as an English teacher, and he showed off his love of British culture by his naming of the dog. Julie is dressed in black, mourning her father's death in 1892. Laertes's presence provides her with some comfort as well as warm memories of her father's associations. Compared with Cassatt's *Little Girl in a Blue Armchair*, Morisot's compositions seem straightforward, spontaneous, and personal observations, never intended for public view. Their charm lies in an intimacy associated with the subjects of her painting rather than, as for Cassatt, in an ostentatiously modern structure and allusion to the history of art.

Manet's *The Balcony* (fig. 84) offers another interesting connection between Berthe Morisot and canine companions.[45] It shows a group of Parisians looking

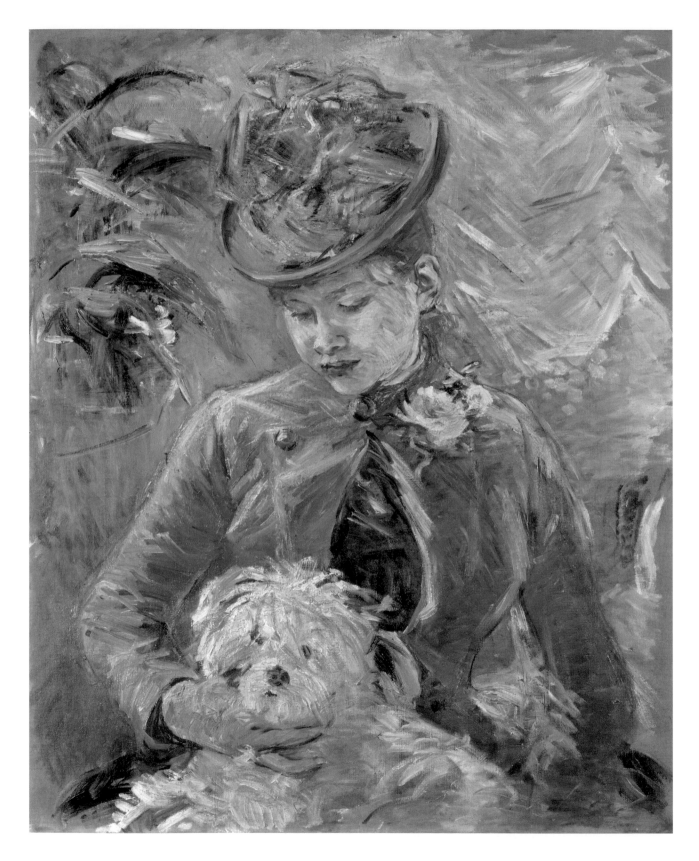

81 Berthe Morisot, *Young Woman with a Dog*, 1887, Armand Hammer Museum, Los Angeles.

82 Berthe Morisot, *Young Woman with Greyhound*, 1893, Musée Marmottan, Paris.

out from an apartment balcony accompanied in the foreground by a dwarf spaniel (the ancestor of today's Phalene) with a ribbon in its hair. Unknown to most viewers at the time, the figures were all friends or members of the Manet family: Madame Manet's son, Léon Leenhoff, is in the shadows; the violinist Fanny Claus stands to the right holding a closed parasol; to the left, with a cigarette, is the landscape painter Antoine Guillemet. The woman seated in the foreground is Berthe Morisot, who was already a family friend but not yet married to Eugène. The picture is striking for its combination of taut formality in compositional design with looseness and informality in rendering of individual forms, particularly in areas of hair, clothing, and accessories. It also

83 Francisco de Goya, *Majas on a Balcony*, c. 1808–12, The Metropolitan Museum of Art, H. O. Havemeyer Collection, Bequest of Mrs. H. O. Havemeyer.

alludes to Goya's *Majas on a Balcony* (fig. 83), which Manet could have seen in various versions either in Paris or on his trip to Spain. While Manet's earlier reference to Goya suggested a parallel (figs. 16 and 17), Manet here was using an ironic contrast, for his circle was nothing if not outwardly respectable, compared to Goya's courtesans and rakes.

The Balcony was conceived during Manet's summer at Boulogne, the location of his *Déjeuner dans l'atelier* (fig. 19), painted just before it. Both testify to his gradual acceptance of working directly from modern life, ostensibly in open air. Symptomatic of this progression is the naturalism of the cat in the *Déjeuner* and now the dog in *The Balcony*. As already emphasized, the lap dog was associated with bourgeois ladies, or those who aspired to be. This particular breed of toy spaniel was the one featured in Bonnardot's *Des Petits Chiens des dames*, which recorded their spread among Parisians.[46] In *The Balcony*, the dog looks away from its toy ball, which sits precariously close to the edge. It is

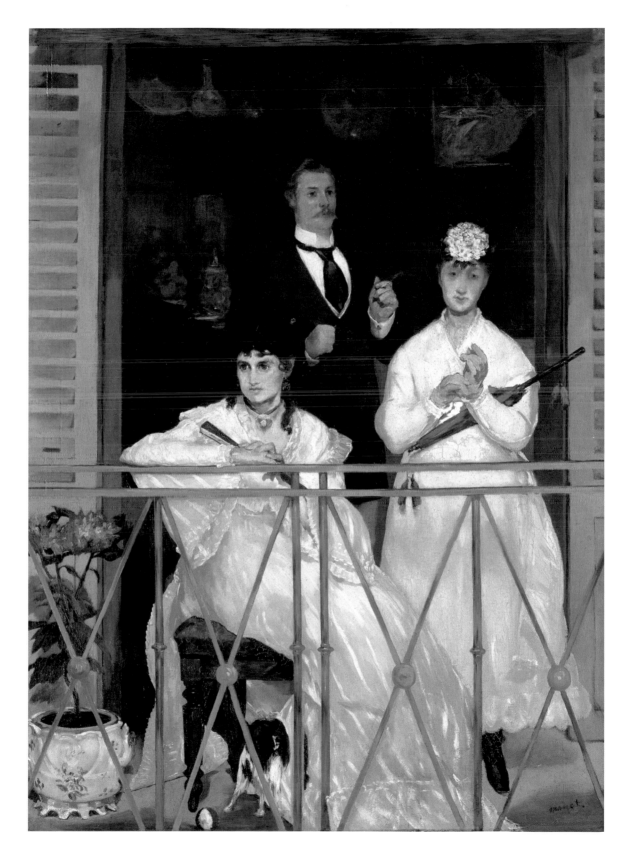

84 Edouard Manet, *The Balcony*, 1868–69, Musée d'Orsay, Paris.

presumably Morisot's pet, since she is the figure closest to it. There is no comparable animal in Goya's *Majas on a Balcony*, although he did include animals in some of his portraits.[47] Had he chosen to depict a pet here, it would surely have been a cat, to accord with the nature of his characters.

The dog's presence in *The Balcony* seems completely opposed to *Olympia*'s cat, with its associations of sexuality and avant-garde artists. As discussed above, in *Olympia* Manet transformed the Duke of Urbino's gentle mistress, with her faithful puppy, into a crassly commercial prostitute with promiscuous pet. Here, he performed the reverse metamorphosis. Goya's mysterious scene of alluring Majas becomes a brightly day-lit episode of post-prandial relaxation. It is only through Morisot's especially prominent eyes that Manet might, if at all, be identifying her as an artist. Yet somewhat like her apartment dog, she would be an artist confined behind the railing, in her case by social status and gender. Her range of subjects would be limited primarily to domestic scenes, usually indoors, relating to family and friends.[48] In 1869, no one could have known that Morisot would make exemplary Impressionist paintings primarily within those confines. Manet himself felt her talents needed guidance, and as her teacher he sometimes "corrected" her early work by painting over parts of it. At that time, only the obstacles to a serious career would have been apparent. So in this sense, the reference in *The Balcony* to Spanish painting may include wry and possibly parodic echoes of that ultimate statement of an artist's fealty to his master (dog included), Velázquez's *Las Meninas*. In more ways than one, then, Morisot's lap dog is an anti-cat, refusing the symbolic readings so important for Manet's cats, emphasizing domesticity rather than independence.

facing page Edouard Manet, *The Balcony* (detail of fig. 84).

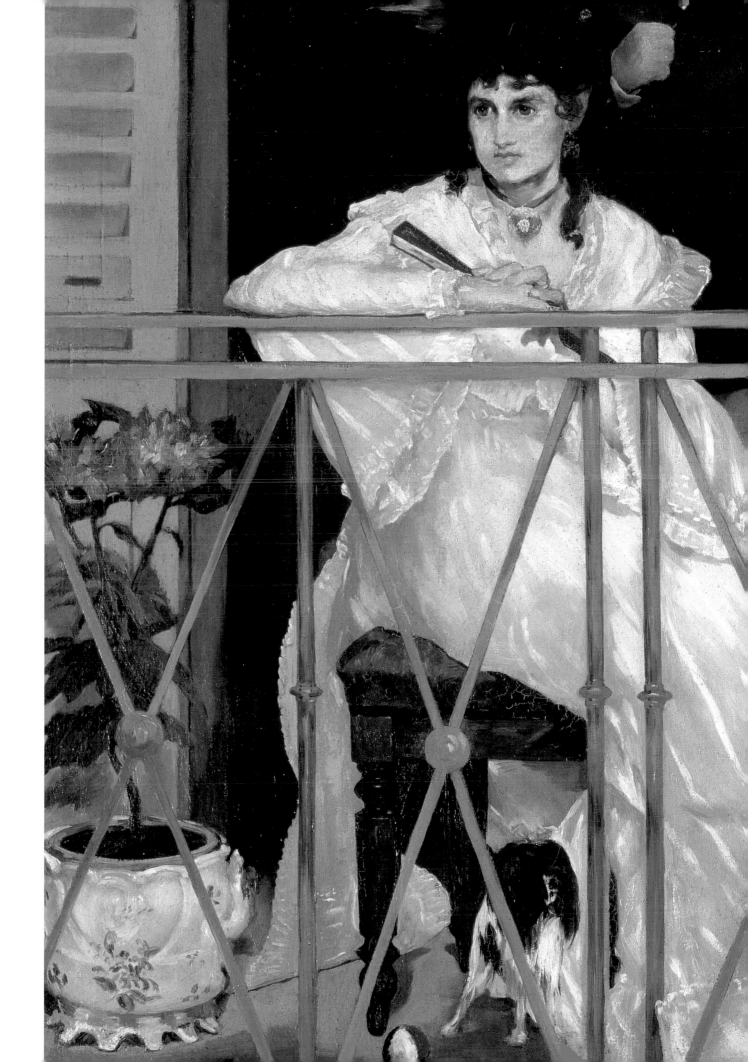

4

Renoir's Love Affair with Cats

\mathcal{M}anet's greatest Impressionist rival for paintings of cats was Renoir, whose cats are almost always represented as adorable pets, released from the weight of symbolism (there is one exception).[1] Nonetheless, a great deal can be learned from their appearance. One of the most beautiful of Renoir's cats is in his *Sleeping Girl with Cat* (fig. 85), over one meter high.[2] The luscious blues and vibrant reds of this confection make the whole painting as appealing as the young woman who holds the cat in her lap as she naps. For the presumed male viewer, there are obvious erotic fantasies of female innocence. The drooping shoulder strap implies the possible exposure of an adolescent breast. But the girl's slumber means that the sexual interest she awakens is unwitting on her part. The cat embodies two aspects of Renoir's sophisticated play – it is both innocent and risqué. While delighted to loll in comfort on mistress's lap, pussy still can't help insinuating sex.

But there is even more that warrants arousal. The cat is at the center of visual effects for which Impressionism is famous. It is true that a certain kind of domestic cat, called a *chartreux*, has gray-blue fur.[3] But even if Renoir set himself to represent that type, his colors are not realistic. The cat's fur can no more be the bright blue of Renoir's pigment than the girl's blue skirt can be white in places where Renoir has used white strokes across it. Traditions of art had accustomed viewers to read those whites as highlighting, where light falls upon a surface helping one to read it in space and to make its color sparkle. The play of blue over the cat's fur makes sense only if one reads it in similar, but reversed terms. In areas of shadow the cat's darker colors are exaggerated. The use of blue in shadows is a notable Impressionist invention, prominent in Monet's snow scenes.[4] There, it indicates reflections of sky in areas where lack of direct light could make them plausible. So in Renoir's picture, the blue skirt is the source for the intense shades on kitty's fur. While the cat's true color is almost disguised, that is to the advantage of Renoir's art. The Impressionist use of color for its own sake is part of its fascination, a key to its grip on the viewer's attention.

facing page Pierre-Auguste Renoir, *Sleeping Girl with Cat* (detail of fig. 85).

The sensual allure of Renoir's art thus goes beyond his choice of subject, pose, and pet. It is the essence of his pictorial forms and exquisite craft, hence also of his artistic aims. The delicate softness of Renoir's brushstrokes is paralleled by the downy fur they represent. Nowhere is the relationship between sight and touch more palpable. Like the sleeping girl seen as a lustful male fantasy, the reality of pets (and paintings) is that they are commodities acquired for the pleasures they provide. The generosity and subtlety with which Renoir applied his paint appeals to appetite and desire as much as do the objects such pictures introduce to the imagination. The painting is a precious and comforting resource, over which the eye languidly lingers. It is as much a luxury object as are the things it portrays; desire for both of them converges. That is the heart of Renoir's continuing appeal to the viewer's consciousness and to the collector's wallet.

Several other paintings of cats have similar characteristics, yet each of them is fresh. *Geraniums and Cats* (fig. 86) echoes Manet's etching of *Cat and Flowers* (fig. 18b) but goes far beyond it. A pair of tiger-striped kittens is found next to a florid geranium in a magnificent Chinese planter.[5] The two tempted tabbies have got into a troublesome trap. One has plumped itself in the sewing-basket, while the other unravels some yarn. Many contemporary images present cats in baskets, as in the etching by Eugène Lambert (fig. 87). In Dutch painting of the seventeenth century, such playful pets would teach a moral lesson – a twist on "When the cat's away the mice will play" meant to reprimand an inattentive housemaid (fig. 88). In Renoir's case, the morality is probably reversed. The freedom enjoyed by these devilish delinquents is something one might admire and even envy. Their cuteness, like those of mischievous children, is endearing. A relationship with pets can bolster a sense of human superiority, and some pet owners are freer with their animals than with their toddlers. Renoir's picture thus appeals to the generous instincts of the self. So in addition to the seductions of brilliant color in his prolific potted plant, Renoir's tabby theme is satisfying morally.

A painting that combines characteristics of *Sleeping Girl* and *Geraniums with Cat* is *Girl with a Cat* (fig. 89).[6] The young woman, probably Aline Charigot, is intrigued by the curiosity of her tiger-colored cat. He is stretched on his hind legs reaching up toward the foliage of a large house plant. A piano in the background implies that Aline has momentarily stopped her practicing of scales. You can't tell if she intends to indulge the cat's antic or prevent it. In any case, she is absorbed enough in her surveillance that her blouse has accidentally – though predictably in Renoir – descended off the shoulder, suggesting the fruits of

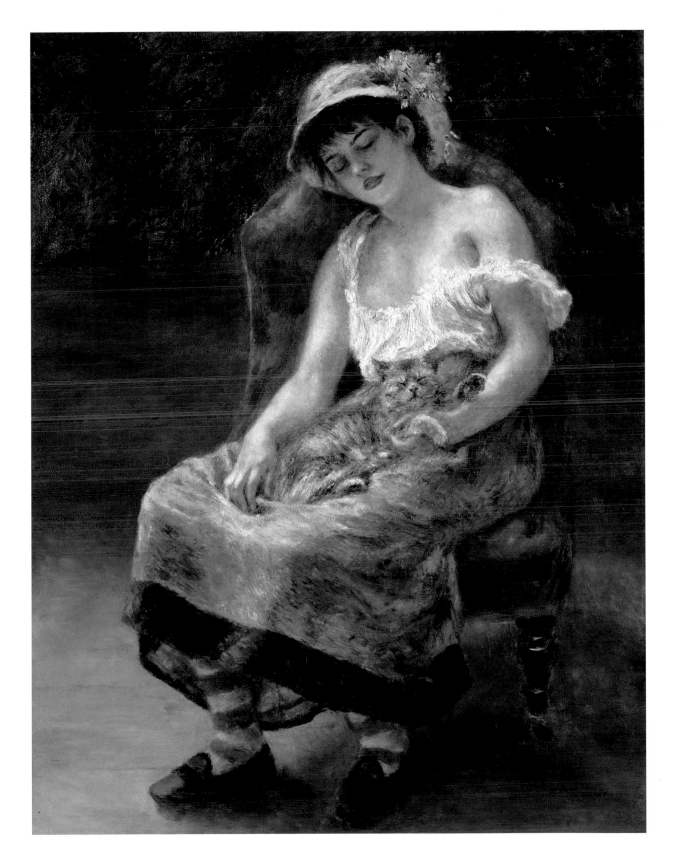

85 Pierre-Auguste Renoir, *Sleeping Girl with Cat*, 1880, Sterling and Francine Clark Art Institute, Williamstown, Massachusetts.

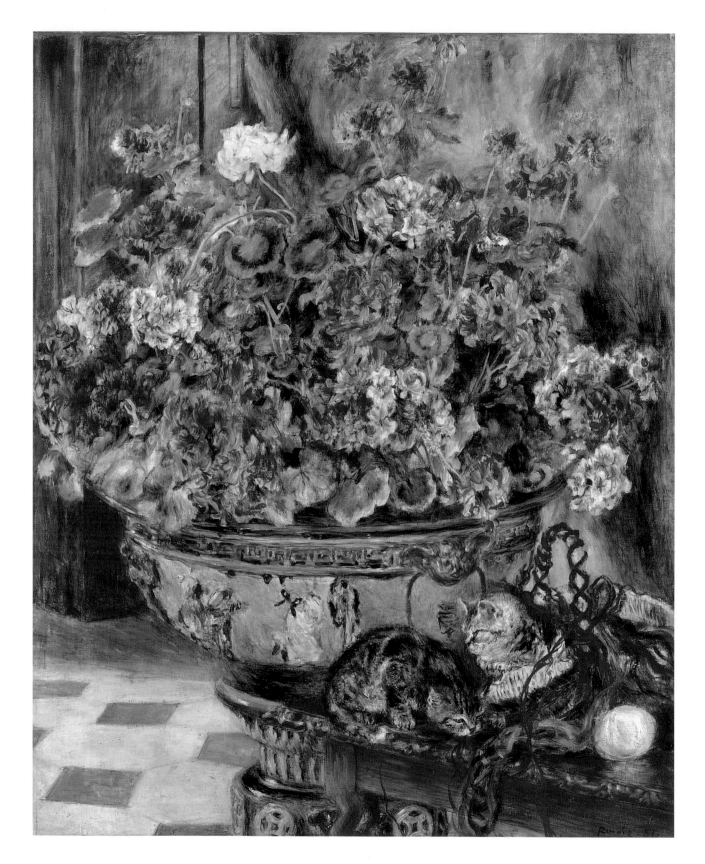

86 Pierre-Auguste Renoir, *Geraniums and Cats*, *c.* 1880, private collection, New York.

ample femininity to the artist's ever-ogling gaze. In this, Renoir repeats an age-old device that appealed especially to Greuze, mentioned earlier for his use of a family dog. Note how in *The Punished Son* (fig. 47) the eldest sister is so overwrought in mourning her dear departed dad that she forgets to keep her cleavage covered. Another model for the painting can be found in Dutch art, where women playing musical instruments may allude to the pleasures of the senses, as in Johannes Vermeer's *Lady at the Virginals* (National Gallery, London).

Despite his exploitative tactics, Renoir claimed to have reservations about admiring women solely for their flesh, as in a statement quoted by his son. Renoir said: "I have a horror of the word 'flesh,' which has become so shopworn. Why not 'meat,' while they're about it? What I like is skin, a young girl's skin that is pink and shows that she has a good circulation."[7] What Renoir thought of cat fur is recorded only in pigment, but the emphasis is similarly surface-centered. The dramatic incident of the music-stopping tabby is almost overshadowed by Renoir's expressive brush. The top register of the painting is

89 Pierre-Auguste Renoir, *Girl with a Cat*, *c.* 1882, private collection

90　Pierre-Auguste Renoir, *Woman with Cat, c.* 1882, National Gallery of Art, Washington,
Gift of Mr. and Mrs. Benjamin E. Levy.

a clatter of strokes, suggesting far-flying fur balls freely flung about, barely assembling into identifiable forms. In keeping with the picture's musical theme, one might say their harmoniousness plays out abstractly, as patches of pure-pitched color vibrancy echoing the tones of the kitten's coat.

Renoir's pigment sits boldly on the surface of his canvas, often reading as material from the tube or palette rather than as the object it represents. In such cases, it calls attention to the artist's gestures and the physical processes through which he worked. Before Impressionism, and still at the official academies, such free-form, sketch-like paint handling was discouraged in favor of objective-seeming and smoothly crafted illusions of reality. Evidence of the artist's touch should be suppressed so that the artist's "presence," manifest through such physical evidence, would not interfere with convincing realism. Arguing to the contrary, Zola (a strong supporter of Impressionism) claimed that art was "a corner of nature seen through a temperament."[8] That is, the artist begins by observing nature, but expresses it through personal vision – leaving an individual, distinct imprint as though physically upon it. In Zola's view, successful paintings bear a unique "signature" in the way paint has been handled, beyond the impersonal evenness of academic formula or photographic reproduction.

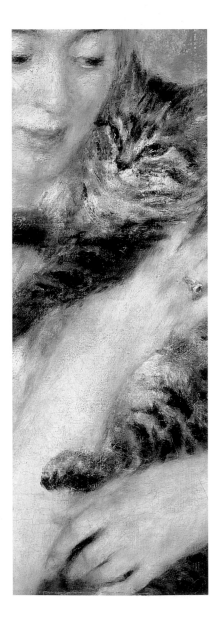

Pierre-Auguste Renoir, *Woman with Cat* (detail of fig. 90).

This modern conception of art allows artists the freedom to subjugate the world to their aesthetic desires. They exercise both a rough and sensitive creative power over it. Stated in such terms, its appeal to Renoir's masculine sense of self is obvious. Its relation to his preoccupation with cats is similar. In emphasizing immediate sensory experiences, his work promises effortless gratification. So that in responding to a picture such as *Woman with Cat* (fig. 90), in which the physical contact between a young woman's cheek and a cat's fur is the principal event depicted, the viewer is able to experience that pleasure vicariously, without wanting more – unless or until curiosity has been exhausted. And it is true that many of Renoir's paintings seem to go for the easy shot rather than sustained reflection. Only with the insight gained from close study can patterns be recognized. For example, isn't Renoir's treatment of cats and women related

to the pictorial exhibitionism of Manet's *Olympia*? So would it be fair now to say that Renoir's brilliantly sketched creations are promiscuous displays of artistic vigor and verve?

In contemporary essays on animal intelligence, the mischievousness of cats was considered a positive sign of their mental capacities. An illustration of cats trying to open an armoire (fig. 91) has similarities to Renoir's *Girl with a Cat*, suggesting that Renoir's inquisitive kitty, along with Aline's wayward blouse, was a familiar visual device. The cat's intelligence and the innocence of domestic animals are of course child-like. In fact, the physical and behavioral resemblance between pets and children is recognized by pet professionals, who call it *neoteny*.[9] Over the centuries, breeders have selected cats and dogs for this characteristic. Comparing their behavior to the pictorial freedom of artists may seem to stretch credibility, but – as discussed in relation to Courbet's *Studio of the Painter* (fig. 11) – such comparisons are meaningful. Thus Renoir's cat scenes playfully rehearse pleasurable and self-affirming associations – the innocence of a young woman so entranced by her cat (or lost in sleep) that she allows her straps to slip; the sly freedom of the artist to transform such trivia into the most suave and seductive expression of pictorial potency.

91 Anonymous, *Cats Opening an Armoire*, wood engraving from Ernest Menault, *L'Intelligence des animaux*, Paris, 1869, p. 267.

Renoir's paintings of girls and cats are framed chronologically by two other important paintings with cats, one early and one late. These two are as different from each other as they are from the group. The first is *Boy with a Cat* (fig. 92), painted in 1868–69.[10] A rare instance of the male nude in Renoir's work, it was executed at a time when Renoir made a number of full-length figures, including portraits. A revealing comparison can be made with the *Bather with Griffon* (fig. 68), the portrayal of Renoir's mistress Lise, who updates and domesticates the nude goddess theme. How different is the *Boy with a Cat*, with its lusty exposure of young adolescent male flesh, the sensuality of which is emphasized by the hugging physical contact between model and animal.

The picture raises a number of issues, all of which are inflected by the cat's presence. This creature, which often signifies sexuality, here plays a double and deliberately ambiguous role, again combining innocence and risk. On the

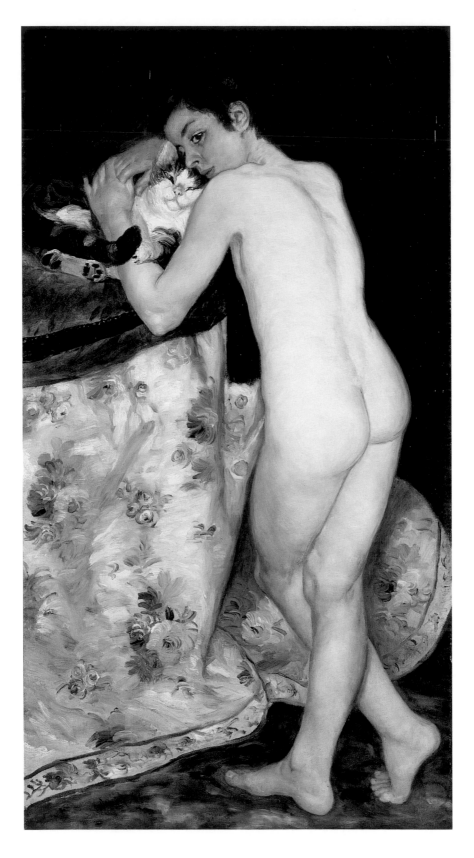

92 Pierre-Auguste Renoir, *Boy with a Cat*, 1868–69, Musée d'Orsay, Paris.

one hand, it ostensibly elaborates a domestic setting, as the boy's body is seen against the lush fabric of a dressing-table on which the cat sits. On the other, its inevitable sexual allusion may have a more closeted context, for at this time Renoir was sharing a live-in studio with Frédéric Bazille. The latter's probable homosexuality, although never public, seems barely hidden below the surface in his own pictures of young male nudes.[11] Renoir's rather pale and dry portrayal of his model corresponds generally to Bazille's stylistic treatment, influenced by Manet.[12] Perhaps it also implies Renoir's own chaste attitude in this naked presence. While thus temporarily participating with Bazille in the male nude theme – it was still a traditional studio exercise among most figure painters – Renoir introduced new and contradictory possibilities by way of the cat. The question is whether the animal's presence heightens or diminishes the sexual possibilities that someone who knew Bazille could imagine. I believe the cat does both, though Renoir's exact intention will never be known. I hasten to add that there is no evidence whatsoever of any other than social bonding between Bazille and Renoir. Still, given the robust displays of masculine attitude found elsewhere in Renoir's work, it is possible that the boy model's cat embodies an attempt to diffuse the sexual tension a naked boy suggests while making explicit the reasons for that tension in the first place.

A considerably later painting reveals that when Renoir consciously used a cat to be symbolic, his intentions had radically changed. Perhaps fatherhood inspired the seriousness Renoir imparted to his picture of the nursing Aline entitled *Maternity* (fig. 93).[13] The painting followed the birth in March 1885 of their first child, Pierre. The composition became a major project, with preparatory drawings (an unusual step for an Impressionist, who usually painted directly) and three different oils. At the picture's center is little Pierre's exposure of his genitals as he clutches his foot while suckling. The innocence of this gesture, which Renoir probably noticed with pride, helps to make the rest of the painting believable. The cat in the lower right-hand corner provides a seemingly natural adjunct to Aline's new maternal activity. Licking her coat, she shows how animals instinctively know the proper rituals for personal hygiene and perpetuation of the species. Aline's motherly duties fall within the same category of animal practice. Renoir did once say that he liked women who wiped their own children's bottoms. What he meant was that he preferred them as instinctual creatures fulfilling biological destiny.[14] So Renoir's cat provided Aline with positive reinforcement for her new-found domesticity.

It is again in the painting of Greuze a century earlier that such obvious devices can be found. *The Village Betrothal* (fig. 94) shows a young man welcomed into

93 Pierre-Auguste Renoir, *Maternity*, 1886, private collection.

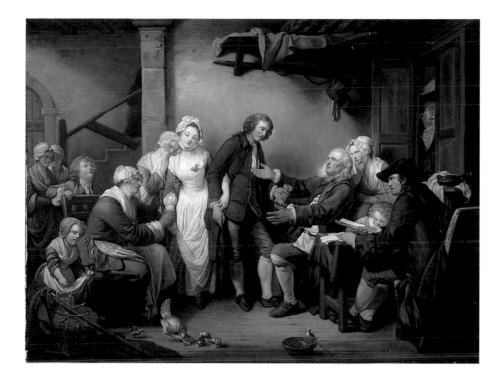

94 Jean Baptiste Greuze, *The Village Betrothal*, 1761, Musée du Louvre, Paris.

the family of his intended. There is good feeling all around, with congratulations and hand-holding, particularly between mother and daughter. Exemplifying the natural destiny that awaits the couple, and that the bride-to-be's family has already fulfilled, a mother hen tending her chicks inhabits the foreground. In an eighteenth-century village, poultry could easily wander into the parlor. Even in the more modern environment of Renoir's house in Essoyes, Aline's home town in the Champagne region, farm animals would have been available. There were hens and chicks in Monet's yard at suburban Argenteuil, where both Manet and Renoir portrayed the Monet family in the garden.[15] But for this picture, Renoir turned rather to the household cat, no doubt because he liked the idea of its once free morals now attuned to family and home. (Is this again an instance of the cat as an artist's *alter ego*?) Renoir was adopting the more recent idea of the cat confirmed by Eugène Lambert, whose etching of a mother cat and brood held place of honor at the front of his book on cats and dogs (fig. 95). The print's title was, significantly, *The Good Mother*.

It is understandable that as cats became popular in bourgeois families, their endearing and maternal qualities overtook their sexual reputations. What parent

LA BONNE MÈRE

95 Eugène Lambert, *The Good Mother*, etching, frontispiece from Gaspar Georges Pescow de Cherville, *Les Chiens et les chats d'Eugène Lambert*, Paris, 1888.

would want a child to hear that Minette (one out of three French cats is still named Minou or Minette) prowled Parisian rooftops after midnight? The cat's evolution in Renoir followed a similar route, just as his image of Aline in *Maternity* suddenly resembled a Renaissance Madonna more than a fashionable coquette. Renoir's style had changed from the free-flowing, sensually brushed surfaces of just a few years earlier to the now drier handling and tighter drawing of what art historians have called his Sour Style. (For this work it should be called his Chaste Style.) By evoking paintings of the Renaissance, Renoir hoped to assure himself a lasting position in the history of art. On more levels than one, he was renouncing youthful ways for respectability.

Fortunately for his sales, Renoir did not persist in this unpleasant and pretentious style. Among others, his dealer Durand-Ruel tried to talk him out of it.[16] More likely, the futility of forever repressing a rampant libido is what brought him back to breasts and bottoms when he could hire models or persuade his children's nannies to pose. The post-partum (and in 1890, married) Aline almost completely exited his imagery. And as to frisky felines, never again would they so prominently a-purr.

facing page Pierre-Auguste Renoir, *Boy with a Cat* (detail of fig. 92).

POSTSCRIPT AND ACKNOWLEDGMENTS

*W*riting about Impressionist cats and dogs was far more rewarding than I had expected. Pets are almost everywhere in Impressionism. And Impressionist painters made fascinating associations between animals and their keepers while themselves revealing a wide range of intentions. The artists' sharp observation of the seemingly banal animal presence in the human world brings people closer to that world than I had at first imagined. I can only hope that, like the Impressionists who created great art from the seemingly everyday, I shall have inspired renewed attention to and further reflections on a largely overlooked feature of their work.

Of course, this book does not pretend to mention all Impressionist paintings of pets. While focusing on those I found most interesting, I have omitted many more conventional portraits of figures with domestic animals. Except for their up-to-date Impressionist color and brushwork, pictures such as Renoir's *Mademoiselle Charlotte Berthier* (fig. 96), showing Caillebotte's mistress posing with a havanese or similar terrier (could she be the woman in the *Pont de l'Europe*?), fall within an artistic tradition as old as the practice of pet-keeping itself.[1] Nor have I discussed the pet portrait as such – that is, without a human figure – although it was a widely practiced specialty.[2] In almost all of the Impressionist paintings considered here, dogs or cats accompany humans. In almost all previous books on animals in art, the examples focus primarily on the animals alone.

In most of the pictures I have chosen, the pets undoubtedly had names and were portrayed as they looked in life. In few of those paintings was the animal the principal subject – a significant exception being Courbet's *Greyhounds of the Comte de Choiseul* (fig. 52). A number of portraits of dogs alone – there are very few of cats which I have seen – do exist among the major Impressionists, and it seems fair to acknowledge their existence. In his book *The Dog in Art from Rococo to Post-Modernism* (New York, 1988), Robert Rosenblum touched on the best examples, especially that of Tama (which means jewel in Japanese), of the Japanese Chin breed, which belonged to the art collector Henri Cernuschi.[3] Cernuschi's collection of Asian porcelains forms the core of the eponymous

facing page Edouard Manet, *The Railroad: Gare Saint-Lazare* (detail of fig. 80).

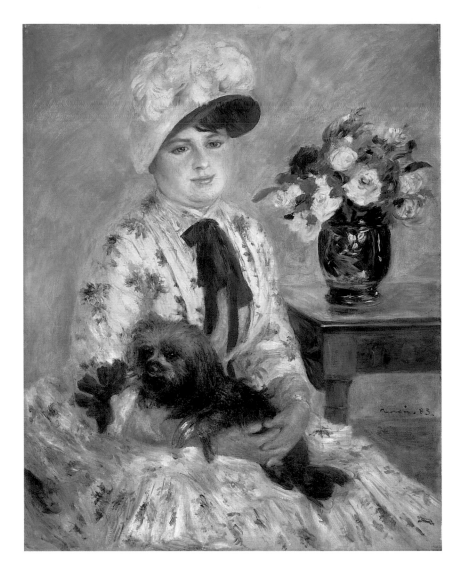

96 Pierre-Auguste
Renoir, *Mademoiselle
Charlotte Berthier*, 1883,
National Gallery of Art,
Washington, Gift of
Angelina Wertheim
Frink.

Parisian museum in his former town house. Surely Tama was as precious an import from the exotic Far East as any other *objet d'art*. He was portrayed by both Manet (fig. 97) and Renoir (*c.* 1876, Sterling and Francine Clark Institute, Williamstown, Mass.), Manet evoking the Impressionist infatuation with Japanese prints through the lettering of the dog's name at the top of his painting and the Japanese doll in its foreground.

The idea for this book came from teaching a course while I was writing my book on Impressionism for Phaidon's "Art and Ideas" series. As I realized the specificity with which Impressionist painters had rendered different breeds of dog, I began to ask if students could identify them. One dog-loving student in particular, Stephanie Gress, recognized many. I also want to thank my cousin,

97 Edouard Manet, *Tama*, c. 1875, National Gallery of Art, Washington, Collection of Mr. and Mrs. Paul Mellon.

Katherine Wolfthal, for introducing me some years ago to the pleasures of cats. Since I grew up with dogs, cats were a more recent discovery. A number of friends and colleagues read the manuscript: thanks especially to Ron and Stephanie Gordon, Conway Lloyd Morgan, Carol Strickland, and Catherine Soussloff. In addition, Gillian Malpass, Sandy Chapman, Ruth Thackeray, Robert Rosenblum, Gary Tinterow, Colin Bailey, Albert Kostenevich, Annette Lloyd-Morgan, Christine Mehring, Stewart Bodner, as well as the staff at various museums and at the New York Public Library have provided essential advice and assistance in putting together the final product and obtaining photographs. I also want to express gratitude for the advice and cooperation I received from experts, particularly concerning types of dog: Barbara Kolk, Ron Rella, and Ann

Sergi at the American Kennel Club made me realize that identifying historical breeds is no simple matter. Finally, although this book's sentimental dedication is to animals to whom I once was close, I want especially to thank the human members of my family. My wife, Liliane, son, Henry, and daughter, Delphine, have had their say about every element of the book and participated keenly in each decision. I am grateful that they have been as generous with their encouragement as with their criticisms.

There are a number of books on animals in art, as well as some scholarly articles, several of which focus on cats or dogs. I have benefited greatly from reading all of them, as I am sure their authors will perceive. Such works are listed in my bibliography, with further references in the notes. This book, in its narrower focus on Impressionism, has given me the opportunity to analyze and appreciate individual paintings more deeply than is usually the case in general surveys; it has also enabled me to explore relationships between the works and their historical times.

In a broader sense, I was also inspired by two recent books on domestic animal consciousness. One is Anny Duperey's *Les Chats de hasard* (Paris, 1999), a moving memoir of what an actress and writer owed to her feline companions during a phase in her life when she was struggling to accept her past. It was in her book that I first encountered the expression, "person-cat." I understand her idea to be quite different from the term "cat-person" (with a hyphen, as opposed to cat person, or lover, without the hyphen), which evokes horror movies, as in wolf-man and its ilk. The other text is Jeffrey Moussaieff Masson's *Dogs Never Lie about Love* (New York, 1997), in which a Freudian writer on psychiatry tries to fathom the superiority of canine morality. At the end of his preface, Dr. Masson claims to be one of the first scientific writers since 1872, when Darwin's *The Expression of the Emotions in Man and Animals* was published, to take the emotional lives of animals seriously. The date of Darwin's book is particularly relevant here: it falls directly within the period of art that has been my focus. The French translation of Darwin's book appeared in 1874; the first Impressionist exhibition was held the same year.

James H. Rubin
New York City, 2002

NOTES

All translations are my own unless otherwise stated. All works are oil on canvas unless otherwise indicated.

1 Beasts Compared with Man

1 Paul G. Bahn and Jean Vertut, *Images of the Ice Age*, Leicester, 1988, pp. 150–76, and Paul G. Bahn, *The Cambridge Illustrated History of Prehistoric Art*, Cambridge and New York, 1998, esp. pp. 225–49. See also Ann Sieveking, *The Cave Artists*, London, 1979, pp. 98–132 and pp. 165–88.

2 André Parrot, *Nineveh and Babylon*, trans. Stuart Gilbert and James Emmons, London, 1961, pp. 54–61; Jessica Rawson, ed., *Animals in Art from the British Museum*, London, 1977, pp. 13–14.

3 Rawson, ed., *Animals in Art*, p. 50, and Kenneth Clark, *Animals and Men: Their Relationship as Reflected in Western Art from Prehistory to the Present Day,* London and New York, 1977, pp. 74–75.

4 Jaromir Malck, *The Cat in Ancient Egypt*, London, 1993, pp. 95–99; Rawson, ed., *Animals in Art*, p. 49.

5 Jules Husson, called Champfleury, *Les Chats*, Paris, 1868, p. 22.

6 Patrick F. Houlihan, *The Animal World of the Pharaohs*, London and New York, 1996, pp. 89–90; Juliet Clutton-Brock, *The British Museum Book of Cats: Ancient and Modern*, London, 1988, pp. 36–37. The frequently quoted source for stories about Egyptians' love of animals was the ancient Roman historian Herodotus, from about 450 B.C.

7 See *Leonardo da Vinci: Anatomical Drawings from the Royal Library, Windsor Castle*, exh. cat., The Metropolitan Museum of Art, New York, 1983, pp. 135–41.

8 Colin Eisler, *Dürer's Animals*, Washington, D.C., 1991, pp. 109–12.

9 Pierre Rosenberg et al., *Chardin*, exh. cat., Royal Academy of Arts, London, and The Metropolitan Museum of Art, New York, 1999–2000, no. 2. *The Ray* was Chardin's reception piece at the Académie. Royale de Peinture et de Sculpture in 1728.

10 Ronald Paulson, *Hogarth*, 3 vols., New Brunswick, N.J., 1991–93, II, pp. 260–64. Paulson makes the point that Hogarth's role as artist-watchdog is manifested through his art of social commentary. He also cites interpretations of the dog as a spiritual animal connected with Freemasonry.

11 Jennifer Montagu, *The Expression of the Passions: The Origin and Influence of Charles Le Brun's Conference sur l'Expression générale et particulière*, New Haven and London, 1994; *Charles Le Brun, 1619–1690: Peintre et dessinateur*, exh. cat., Musée National du Château de Versailles, Paris, 1963, nos. 133 35.

12 Charles Darwin, *The Expression of the Emotions in Man and Animals* (1872), ed. Paul Ekman, London, 1998, p. 7.

13 Buffon is quoted in Henri Larousse, *Dictionnaire universelle du XIXe siècle*, Paris, 1875, s.v. *chat* and *chien*.

14 Kathleen Kete, *The Beast in the Boudoir: Petkeeping in Nineteenth-Century Paris*, Berkeley and Los Angeles, 1994, pp. 41–42. Like so many French fads, the growth of pet-keeping took off first in England. Not surprisingly, the first scholarly book on the topic was about the British; see Harriet Ritvo, *The Animal Estate: The English and Other Creatures in the Victorian Age*, Cambridge, Mass., 1987.

15 Kete, *The Beast in the Boudoir*, p. 53, for Paris dog population in the 1840s. Estimates of current populations come from contemporary media reports: for Paris, National Public Radio News, December 2001; for New York, Denny Lee, "Where the Dogs Are: The Favorite Zip Codes," *New York Times*, Sunday, February 10, 2002, Neighborhood Report, City Section, 14, p. 4. The figure for Manhattan is based on dog licenses issued in the borough as recorded by the New York City Department of Health.

16 This claim was made in an article from *L'Illustration*, 1874, p. 296, cited by Richard Thomson, "'Les Quat' Pattes': The Image of the Dog in Late Nineteenth-Century French Art," *Art History*, V/3, 1982, p. 324. I am indebted to the research in

Thomson's article, although in certain cases my conclusions are different.

17 The following is based on Kete, *The Beast in the Boudoir*, pp. 5–21.

18 Kete calls this new status the "*embourgeoisement* of the beast" (ibid., p. 39).

19 Loys Delteil, *Le Peintre-graveur illustré (xix et xx siècles)*, Paris, 1906–30, s.v. Daumier, nos. 607–18.

20 Ibid., s.v. Daumier, nos. 2737–40. There is a lesser-known series by Daumier of 1852 in which he responded to a rabies scare with ten plates excoriating those who called for curbs on dogs (ibid., nos. 2250–59).

2 *The Artist's Special Companions*

1 Margaret A. Seibert, "A Political and a Pictorial Tradition Used in Gustave Courbet's *Real Allegory*," *Art Bulletin*, LXV/2, 1983, pp. 311–16.

2 James H. Rubin, *Courbet* (Art and Ideas), London, 1997, pp. 133–74, on Courbet's *Studio of the Painter* and the Realist Manifesto.

3 Florent Prévost, *Des Animaux d'appartement et de jardin: Oiseaux, poissons, chiens, chats*, Paris, 1861, pp. 168–69.

4 Champfleury, *Les Chats*, Paris, 1868, p. 121.

5 Alphonse Toussenel, *L'Esprit des bêtes: Zoologie passionnelle*, Paris, 1855, p. 231.

6 Prévost, *Des Animaux d'appartement*, p. 169.

7 Quoted in Champfleury, *Les Chats*, p. 117.

8 David Comfort, *The First Pet History of the World*, New York, 1994, p. 201.

9 Seibert, "A Political and a Pictorial Tradition," p. 315, and Champfleury, *Les Chats*, pp. 46–51.

10 James H. Rubin, *Realism and Social Vision in Courbet and Proudhon*, Princeton, 1980, pp. 14–15.

11 Françoise Cachin et al., *Manet, 1832–1883*, exh. cat., The Metropolitan Museum of Art, New York, 1983, no. 64.

12 W. Bürger (Théophile Thoré), *Salons de W. Bürger, 1861–1868*, Paris, 1870, p. 532 (1868).

13 Theodore Reff, *Manet: Olympia*, New York, 1976, pp. 49–50.

14 Jean-Auguste-Dominique Ingres's *Odalisque with Slave*, which exists in two versions (Walters Art Gallery, Baltimore, and Fogg Art Museum, Harvard University, Cambridge, Mass.), is the best example of a harem woman with an African slave and was certainly also the object of Manet's parody, for Ingres was a leader of the conservative art establishment.

15 Champfleury, *Les Chats*, p. 22.

16 Alphonse Toussenel, *L'Esprit des bêtes: Zoologie passionelle*, Paris, 1855, p. 228.

17 "Les Chats," *Les Fleurs du mal*, lxvi, in Charles Baudelaire, *Oeuvres complètes*, ed. Claude Pichois, Paris, 1975, I, p. 66 concludes:

> Ils prennent en songeant les nobles attitudes
> Des grands sphinx allongés au fond des solitudes,
> Qui semblent s'endormir dans un rêve sans fin;
>
> Leurs reins féconds sont pleins d'étincelles magiques,
> Et de parcelles d'or, ainsi qu'un sable fin,
> Etoilent vaguement leurs prunelles mystiques.
>
> (When dreaming, they strike the noble postures
> Of great sphinxes stretched out in depths of solitude,
> And doze off in a reverie without end;
>
> Their fecund loins are filled with magic sparks,
> And bits of gold, sprinkled with fine sand,
> Glisten vaguely in their mystical pupils.)

18 "Viens mon beau chat, sur mon coeur amoureux;/ Retiens les griffes de ta patte,/ Et laisse-moi plonger dans tes beaux yeux." From "Le Chat," *Les Fleurs du mal*, xxxiv, in ibid., p. 35.

19 "Elle endort les plus cruels maux/ Et contient toutes les extases;/ Pour dire les plus longues phrases,/ Elle n'a pas besoin de mots." From "Le Chat," *Les Fleurs du Mal*, li, in ibid., p. 50.

20 Charles Baudelaire, *Le Peintre de la vie modern* (1863), trans. and ed. Jonathan Mayne, *The Painter of Modern Life*, London, 1995, pp. 36–37. Baudelaire's specific reference is to poets, but the implication for visual artists is clear.

21 On "Manette" as a play on the artist's name relating to masculine and feminine aspects of painting, see the important book by Carol Armstrong, *Manet/Manette*, New Haven and London, 2002.

22 Françoise Cachin et al., *Manet, 1823–1883*, exh. cat., The Metropoitan Museum of Art, New York, 1988–89, no. 29.

23 This series of prints was first discussed by Theodore Reff, "The Symbolism of Manet's Frontispiece Etchings," *Burlington Magazine*, CIV, 1962, pp. 182–86. See also James H. Rubin, *Manet's Silence and the Poetics of Bouquets*, London and Cambridge, 1994, pp. 170–71, and Cachin et al., *Manet*, exh. cat., nos. 45–47.

24 See Rubin, *Manet's Silence*, p. 170.

25 Cachin et al., *Manet*, exh. cat., no. 109.

26 Before *The Studio*, Courbet had shown a cat curled up behind

a mixing-bowl to the center left in *The Grain Sifters* (1854–55, Musée des Beaux-Arts, Nantes). Its presence is naturalistic, as in kitchens or other places of domestic labor. There is also a painting by Courbet (Worcester Art Museum, Mass.) showing a woman cradling a cat on its back. It is comparable with one at the Musée d'Orsay of a nude woman, possibly Courbet's mistress Léontine Renaud, cradling a poodle. The latter two paintings confirm the association between lap pets and kept women, which I explore in chapter 3.

27 Courbet referred to this hunter as a poacher, and Klaus Herding demonstrated that the figure was a direct allusion to Louis-Napoléon Bonaparte (Napoleon I's nephew), who after being elected President of the second French republic, but limited to one term only, led a *coup d'état* in 1851, proclaiming the Second Empire and himself Napoleon III. (See Klaus Herding, "The Painter's Studio: Focus of World Events, Focus of Reconciliation," in *Courbet: To Venture Independence*, New Haven and London, 1991, pp. 45–61.) There are numerous dogs in other paintings by Courbet, for example the household pet accompanying Courbet's three sisters in *The Young Ladies of the Village* (1851–52, The Metropolitan Museum of Art, New York), and the beagles and hounds in innumerable Courbet hunting scenes.

28 Self-portraiture was a major genre in Courbet's work. See Marie Thérèse de Forgues et al., *Autoportraits de Courbet*, exh. cat., Musée du Louvre, Paris, 1973.

29 See Rubin, *Realism and Social Vision*, pp. 22–23.

30 Linda Nochlin, "Gustave Courbet's *Meeting*: A Portrait of the Artist as Wandering Jew," *Art Bulletin*, XXXXIX 1967, pp. 209–22.

31 See chapter 3, n. 29, below.

32 Rubin, *Courbet*, pp. 73–100.

33 Cachin et al., *Manet*, exh. cat., no. 38. The connection was first made in the pioneering study by Nils Gosta Sandblad, *Manet: Three Studies in Artistic Conception*, trans. Walter Nash, Lund, 1954. The identities of Manet's friends are discussed in these and many other publications.

34 See Colin B. Bailey et al., *Renoir's Portraits*, exh. cat., National Gallery of Canada, Ottawa, 1997, no. 4.

35 See Paul Hayes Tucker, *The Impressionists at Argenteuil*, exh. cat., National Gallery, Washington, D.C., 2000, no. 36.

36 Juliet Wilson-Bareau, *Manet, Monet: La Gare Saint-Lazare*, exh. cat., Musée d'Orsay, Paris, 1998, pp. 77–101.

37 On the modernization of Paris, see David H. Pinkney, *Napoleon III and the Rebuilding of Paris*, Princeton, 1958.

38 Kirk Varnedoe, *Gustave Caillebotte*, New Haven and London, 1987, p. 78, fig. 15q.

39 Richard Thomson, "'Les Quat' Pattes': The Image of the Dog in Late Nineteenth-Century French Art," *Art History*, V/3, 1982, pp. 331–32, argues that the dog is a stray.

40 The relationship between Caillebotte and photography was established by Kirk Varnedoe and Peter Galassi, "Caillebotte's Space," in Varnedoe, *Caillebotte*, pp. 20–26.

41 Jacques, in *L'Homme libre*, April 12, 1877, quoted by Thomson, "'Les Quat' Pattes,'" p. 331.

42 Baudelaire, trans. and ed. Mayne, *The Painter of Modern Life*, pp. 7–9.

43 Cachin et al., *Manet*, exh. cat., no. 146.

44 On Degas's *Absinthe*, see Jean Sutherland Boggs et al., *Degas*, exh. cat., The Metropolitan Museum of Art, New York, 1988–89, no. 172.

45 Armand Silvestre, quoted in ibid., p. 370.

46 James H. Rubin, *Impressionism* (Art and Ideas), London, 1999, pp. 293–328.

47 Robert L. Herbert et al., *Georges Seurat, 1859–1891*, exh. cat., The Metropolitan Museum of Art, New York, 1991, no. 140.

48 On the literary tradition and symbolic interpretation of the stray dog, see Thomson, "'Les Quat' Pattes,'" p. 334.

49 Kete, *The Beast in the Boudoir*, p. 150, n. 49.

50 In Cézanne's *Déjeuner sur l'herbe* of a few years earlier (c. 1870, Private Collection), the artist had employed a related formula, including a dog. There, he showed himself as part of a picnic party meant, again, to evoke a notorious work by Manet. The latter's *Déjeuner sur l'herbe* (1862–63, Musée d'Orsay, Paris), which had been rejected from the Salon of 1863, was the most controversial painting shown at the Salon des Refusés, an exhibition of excluded works which the government agreed to organize following protests over the jury's severity. In this earlier response to Manet, Cézanne represented himself accompanied by a dog sitting with its back to the viewer while observing the scene. In reusing this strategy for the *Modern Olympia*, Cézanne clearly confirmed its significance for him.

51 Cézanne used a dog in two other group-figure compositions for related meanings. In the *Battle of Love* (c. 1880, National Gallery of Art, Washington, D.C., and other versions), a dog gleefully participates in the sexual excitement. In the *Apotheosis of Delacroix* (c. 1890–94, Musée Granet, Aix-en-Provence), the dog refers to envy, according to John Rewald, *The Paintings of Paul Cézanne: A Catalogue Raisonné*, New York, 1996, I, no. 746, p. 458.

52 Cézanne is said to have made the painting out of irritation following a discussion in which the participants expressed

admiration for Manet's painting. (See *Cézanne*, exh. cat., Philadelphia Museum of Art, 1996, no. 28, p. 132.)

53 See Rubin, *Impressionism*, pp. 370–71.

54 On Cézanne's early work, see Lawrence Gowing et al., *Cézanne: The Early Years*, exh. cat., Royal Academy of Arts, London, Musée d'Orsay, Paris, and National Gallery of Art, Washington, D.C., 1988–89; and Mary Tompkins Lewis, *Cézanne's Early Imagery*, Berkeley and London, 1989.

55 The bather theme recurs at several points in Cézanne's career and was the major project of his later years. There exist drawings, painted studies, and other versions of the theme. The same dog is present in the exquisite study (Musée Granet, Aix-en-Provence) for the Barnes Foundation painting and is modified in the foreground of the concurrent *Female Bathers* (National Gallery, London). On Cézanne's *Bathers*, see Mary Louise Krumrine, *Paul Cézanne: The Bathers*, exh. cat., Kunstmuseum, Basle, 1989.

56 While I was asking myself some of these questions, I discovered they had also occurred to Jean Arrouye, "Cave Canem," in Musée Granet, Aix-en-Provence, *Une Oeuvre de Cézanne*, collection iconotexte, Marseilles, 2000, pp. 21–40.

57 It is repaced by an empty, seemingly unfinished patchwork in the late, large Philadelphia Museum *Bathers*. Perhaps that is the ultimate sign of its integration.

3 *Gone to the Dog's House*

1 Alphonse Toussenel, *L'Esprit des bêtes: Zoologie passionelle*, Paris, 1855, p. 149.

2 As demonstrated in the classic essay by Meyer Schapiro, "Courbet and Popular Imagery: An Essay on Realism and Naïveté" (1941), in *Modern Art, Nineteenth and Twentieth Centuries: Selected Papers*, New York, 1978, pp. 46–85.

3 Charles Baudelaire, *Le Peintre de la vie modern* (1863), trans. and ed. Jonathan Mayne, *The Painter of Modern Life*, London, 1995, p. 8.

4 Jean Sutherland Boggs et al., *Degas*, exh. cat., The Metropolitan Museum of Art, New York, 1988–89, no. 20.

5 Degas added the dog to the composition after he made his preliminary drawings. Yet, sometimes the best thought is an afterthought. As I show (see p. 60), the dog's presence sharpens the impact of the painting's other features.

6 Emile Zola, Preface to *Thérèse Racquin*, Paris, 2nd edn., 1867.

7 Quoted by Henri Loyrette, in his entry for the painting in Boggs et al., *Degas*, exh. cat., p. 82.

8 Marilyn Brown, *Degas and the Business of Art: A Cotton Office in New Orleans*, University Park, Penn., 1994, p. 9, cites the evidence.

9 Linda Nochlin, "A House is not a Home: Degas and the Subversion of the Family," in *Dealing with Degas: Representations of Women and the Politics of Vision*, ed. Griselda Pollock and Richard Kendall, New York, 1992, pp. 42–65.

10 Judges 11: 30–40. See also Henri Loyrette in Boggs et al., *Degas*, exh. cat., no. 26, p. 86.

11 Although absent from the first painting of the pair, the dog does appear in a drawing which preceded the painting (Musée des Beaux-Arts, Lille). Greuze exhibited the drawing at the Salon of 1765, along with a drawing of *The Punished Son* (Musée des Beaux-Arts, Lille), where Diderot commented that the barking dog contributes to the general uproar of the scene. Denis Diderot, "Salon de 1765," in *Les Salons de Diderot*, ed. Jean Seznec and Jean Adhémar, Oxford, 1957–67, II, p. 157.

12 The reference to Degas's attitude toward dogs (cited without source in Linda Nochlin, "Impressionist Portraits and the Construction of Modern Identity," in Bailey et al., *Renoir's Portraits*, exh. cat., p. 69) is from Paul Valéry, "Degas Dance Drawing," in *Degas Manet Morisot: Collected Works of Paul Valéry*, ed. Jackson Matthews, Princeton, 1989, XII, p. 71.

13 Boggs et al., *Degas*, exh. cat., no. 95, p. 157.

14 Florent Prévost, *Des Animaux d'appartement et de jardin: Oiseaux, poissons, chiens, chats*, Paris, 1861, p. 147. The dangers of bulldogs are also cited in Larousse, *Dictionnaire universelle*, s.v. *chien, bouledogue*, p. 87.

15 See Albert G. Kostenevich, *Hidden Treasures Revealed: Impressionist Masterpieces and Other Important French Paintings Preserved by the State Hermitage Museum, St. Petersburg*, trans. from the Russian by Elena Kolesnikova, Catherine A. Fitzpatrick, and Stas Rabinovich, New York, 1995, pp. 68–79.

16 Kostenevich (ibid., p. 71) identifies the figure as Ludovic Halévy, the librettist for Bizet's *Carmen* and a long-standing friend of Degas's.

17 The photograph is attributed to L. Sauvager (ibid., p. 79). Incidentally, Kostenevich identifies Albrecht's breed as a borzoi, a slender Russian wolfhound with longish, whitish fur. By Western European and North American breed standards, Lepic's animal is clearly a greyhound, like that in the photograph. (Nochlin, in Bailey et al., *Renoir's Portraits*, exh. cat., p. 53, repeats Kostenevich's identification.)

18 Gaspar Georges Pescow de Cherville, "Les Chiens à Paris," *L'Illustration*, 1875, p. 26, quoted by Richard Thomson, "'Les

Quat' Pattes' : The Image of the Dog in Late Nineteenth-Century French Art," *Art History*, v/3, 1982, p. 234.

19 Henri Larousse, *Dictionnaire universelle du XIXe siècle*, Paris, 1875, s.v. *chien*, pp. 89–90.

20 Robert Rosenblum, *The Dog in Art from Rococo to Post-Modernism*, New York, 1988, p. 49.

21 On Lepic's *Jupiter*, see ibid., pp. 56–58.

22 Kostenevich, *Hidden Treasures*, p. 70. Note that the rue de Rivoli, visible in the background to the left, was constructed under Napolean I.

23 A few are cited by Thomson, "'Les Quat' Pattes,'" p. 327.

24 See Douglas W. Druick and Peter Zegers, "Scientific Realism: 1873–1881," in Boggs et al., *Degas*, exh. cat., pp. 197–211, esp. pp. 205–06.

25 As in Norma Broude, "Degas' Misogyny," *Art Bulletin*, LIX, 1977, pp. 95–107.

26 James H. Rubin, *Impressionism* (Art and Ideas), London, 1999, p. 214.

27 After this book was in production, a pertinent article on Degas appeared on the internet: Martha Lucy, "Reading the Animal in Degas's Young Spartans," in Conference Papers of The Darwin Effect: Evolution and Nineteenth-Century Visual Culture, ed. Linda Nochlin and Martha Lucy, *Nineteenth-Century Art Worldwide: A Journal of Nineteenth-century Visual Culture*, v/2, no. 2, spring 2003 (http://www.19thc-artworldwide.org).

28 Robert L. Herbert, *Impressionism: Art, Leisure, and Parisian Society*, New Haven and London, 1988, p. 211.

29 Kathleen Kete, *The Beast in the Boudoir: Petkeeping in Nineteenth-Century Paris*, Berkeley and Los Angeles, 1994, pp. 87–88. Space for public bathing was provided for people and their pets in floating bathhouses on the river.

30 There is a wonderful exception to Monet's exclusion of the canine race, his *Madame Paul and Her Dog* (1882, Fogg Art Museum, Harvard University, Cambridge, Mass.). "Follette" belonged to the wife of the Alsatian innkeeper of Monet's hotel at Pourville. This painting and the portrait he made of the innkeeper (1882, Osterreichische Galerie, Vienna) were tributes to his affection for the couple.

31 Colin B. Bailey et al., *Renoir's Portraits*, exh. cat., National Gallery of Canada, Ottawa, 1997, no. 32.

32 Prévost, *Des Animaux d'appartement*, p. 153.

33 Ernest Menault, *L'Intelligence des animaux*, Paris, 1869, p. 271.

34 Alfred Barbou, *Le Chien: Son Histoire, ses exploits et ses aventures*, Paris, 1888, p. 97.

35 The writer was Philarète Chasles, whose memoirs Char-

pentier published posthumously in 1879. Bailey et al., *Renoir's Portraits*, exh. cat., p. 298, n. 66.

36 Eliza E. Rathbone, "Renoir's *Luncheon of the Boating Party*: Tradition and the New," in *Impressionists on the Seine*, exh. cat., Phillips Collection, Washington, D.C., 1996, pp. 13–55.

37 Alfred Bonnardot, *Des Petits Chiens des dames, spécialement de l'epagneul nain*, Paris, 1856, offers advice on how to create a paradise for a lady's dog. (This book is not to be confused with Henry de Kock, *Les Petits Chiens de ces dames*, Paris, 1856.)

38 While it is true that lap dogs are often present in erotic painting, especially of the eighteenth century, as Thomson argues in "'Les Quat' Pattes,'" pp. 328–30, I find that in most nineteenth-century examples the implications are more domestic than erotic. This finding is a basis for my thesis that in the painting of modern life natural presences overtake symbolic ones, even when they do not discard them entirely. Thus while the lap dog is still associated with mistresses, the latter are domesticated ones.

39 Anne Distel, John House, and John Walsh, *Renoir*, exh. cat., Museum of Fine Arts, Boston, 1985–86, no. 87.

40 Bailey et al., *Renoir's Portraits*, exh. cat., no. 62.

41 Thomson, "'Les Quat' Pattes,'" p. 327.

42 Françoise Cachin et al., *Manet, 1832–1883*, exh. cat., The Metropolitan Museum of Art, New York, 1983, no. 133.

43 Alain Clairet, Delphine Montalant, and Yves Rouart, *Berthe Morisot, 1841–1895: Catalogue raisonné de l'oeuvre peint*, Montolivet, 1997, no. 213.

44 Ibid., no. 339. Julie also had a cat, or is at least shown with one in a portrait of her done by Renoir in 1887 (Musée d'Orsay, Paris).

45 Cachin et al., *Manet*, exh. cat., no. 115.

46 Bonnardot, *Des Petits Chiens des dames*.

47 Cachin et al., *Manet*, exh. cat., p. 306, points out the presence of a little dog in a Goya *Portrait of the Duchess of Alba* reproduced in an engraving of 1867.

48 See Anne Higonnet, *Berthe Morisot's Images of Women*, Cambridge, Mass., 1992.

4 Renoir's Love Affair with Cats

1 It should be said that Manet's use of cats was not exclusively symbolic. He was a genuine cat-lover who made many informal studies of his pets.

2 Anne Distel, John House, and John Walsh, *Renoir*, exh. cat., Museum of Fine Arts, Boston, 1985–86, no. 50.

3 Larousse, *Dictonnaire universelle*, s.v. *chat, chartreux*, p. 1064.

4 For many examples in the paintings of Monet and others, see Charles S. Moffett et al., *Impressionists in Winter: Effets de Neige*, exh. cat., Phillips Collection, Washington, D.C., 1998–99.

5 Distel, House, and Walsh, *Renoir*, exh. cat., no. 59.

6 See Kenneth Clark, *Animals and Men: Their Relationship as Reflected in Western Art from Prehistory to the Present Day*, London and New York, 1977, pp. 194–95.

7 Pierre-Auguste Renoir in Jean Renoir, *Renoir, My Father*, Boston, 1962, quoted in Linda Nochlin, *Impressionism and Post-Impressionism, 1874–1904*, Englewood Cliffs, N.J., 1966, pp. 47–48.

8 Zola's famous definition of art was developed in opposition to the political philosopher Pierre-Joseph Proudhon, who made claims for the social utility and responsibility of art. In July and August 1865 Zola reviewed Proudhon's posthumous *Du Principe de l'art et de sa destination sociale* (Paris, 1865) in *Le Salut publique*. See Emile Zola, *Le Bon Combat: De Courbet aux Impressionistes*, ed. Jean-Paul Bouillon, Paris, 1976, p. 38.

9 F. E. Zeuner, *A History of Domesticated Animals*, New York, 1963, cited by Jeffrey Moussaieff Masson, *Dogs Never Lie about Love: Reflections on the Emotional World of Dogs*, New York, 1997, pp. 44–47.

10 Gary Tinterow, Henri Loyrette et al., *Origins of Impressionism*, exh. cat., The Metropolitan Museum of Art, New York, 1994, no. 175.

11 See the judicious discussion of Bazille's homosexuality in Dianne W. Pitman, *Bazille: Purity, Pose and Painting in the 1860s*, University Park, Penn., 1998, pp. 155–56 and esp. 253–54.

12 Gary Tinterow (in Tinterow, Loyrette et al., *Origins of Impressionism*, exh. cat., p. 334), compares *Boy with a Cat* to Bazille's single figure *Fisherman with Net* (1868, Fondation Rau pour le Tiers-Monde, Zurich).

13 Distel, House, and Walsh, *Renoir*, exh. cat., no. 79.

14 Renoir's attitudes toward women are discussed by John House, "Renoir's Worlds," in ibid., pp. 13–14.

15 As in Manet's *The Monet Family in the Garden*, 1874, The Metropolitan Museum of Art, New York (Cachin et al., *Manet*, exh. cat., no. 141) and Renoir's *Camille Monet and Her Son Jean in the Garden at Argenteuil*, 1874, National Gallery of Art, Washington, D.C. (Bailey et al., *Renoir's Portraits*, exh. cat., no. 17).

16 Distel, House, and Walsh, *Renoir*, exh. cat., p. 242.

Postscript and Acknowledgments

1 See chapter 3, n. 29, for an exceptional example of this type in the work of Claude Monet.

2 Most paintings of domestic animals are portraits and are part of a long tradition of either stand-alone representations of beloved animals or of a tradition in which pet-keepers are represented with their pets. Of books on the topic, the most exhaustive is William Secord, *Dog Painting, 1840–1940: A Social History of the Dog in Art, including an important historical overview from earliest times to 1840 when pure-bred dogs became popular*, Woodbridge, Suffolk, 1992.

3 Robert Rosenblum, *The Dog in Art from Rococo to Post-Modernism*, New York, 1988, pp. 52–56.

SELECTED BIBLIOGRAPHY

Arrouye, Jean. "Cave Canem," in Musée Granet, Aix-en-Provence, *Une Oeuvre de Cézanne*, collection iconotexte, Marseilles, 2000, pp. 21–40.

Bailey, Colin B., et al. *Renoir's Portraits*, exh. cat., National Gallery of Canada, Ottawa, 1997.

Baldwin, Robert. "A Bibliography of Dogs in the Humanitites," *Journal of the Delta Society*, v/2, 1985, pp. 6–13.

Barbou, Alfred. *Le Chien: Son Histoire, ses exploits et ses aventures*, Paris, 1888.

Baudelaire, Charles. *Le Peintre de la vie moderne* (1863), trans. and ed. Jonathan Mayne, *The Painter of Modern Life*, London, 1995.

Boggs, Jean Sutherland et al. *Degas*, exh. cat., Metropolitan Museum of Art, New York, 1988–89.

Bonnardot, Alfred. *Des Petits Chiens des dames, spécialement de l'epagneul nain*, Paris, 1856.

Cachin, Françoise et al. *Manet, 1832–1883*, exh. cat., Metropolitan Museum of Art, New York, 1983.

Champfleury. See Husson, Jules.

Cherville, Gaspar Georges Pescow, de. *Les Chiens et les chats d'Eugène Lambert*, Paris, 1888.

Clark, Kenneth. *Animals and Men: Their Relationship as Reflected in Western Art from Prehistory to the Present Day*, London and New York, 1977.

Darwin, Charles. *The Expression of the Emotions in Man and Animals* (1872), ed. Paul Ekman, London, 1998.

Distel, Anne, John House, and John Walsh. *Renoir*, exh. cat., Museum of Fine Arts, Boston, 1985–86.

Eisler, Colin T. *Dürer's Animals*, Washington, D.C., 1991.

Herbert, Robert L. *Impressionism: Art, Leisure, and Parisian Society*, New Haven and London, 1988.

Husson, Jules, called Champfleury. *Les Chats*, Paris, 1868.

Kete, Kathleen. *The Beast in the Boudoir: Petkeeping in Nineteenth-Century Paris*, Berkeley and Los Angeles, 1994.

Kock, Henry de. *Les Petits Chiens de ces dames*, Paris, 1856.

Kostenevich, Albert G. *Hidden Treasures Revealed: Impressionist Masterpieces and Other Important French Paintings Preserved by the State Hermitage Museum, St. Petersburg*, trans. Elena Kolesnikova, Catherine A. Fitzpatrick, and Stas Rabinovich, New York, 1995.

Larousse, Henri. *Dictionnaire universelle du XIXe siècle*, Paris, 1875.

Menault, Ernest. *L'Intelligence des animaux*, Paris, 1869.

Prévost, Florent. *Des Animaux d'appartement et de jardin: Oiseaux, poissons, chiens, chats*, Paris, 1861.

Rawson, Jessica, ed. *Animals in Art from the British Museum*, London, 1977.

Reff, Theodore. "The Symbolism of Manet's Frontispiece Etchings," *Burlington Magazine*, CIV, 1962, pp. 182–86.

Ritvo, Harriet. *The Animal Estate: The English and Other Creatures in the Victorian Age*, Cambridge, Mass., 1987.

Rosenblum, Robert. *The Dog in Art from Rococo to Post-Modernism*, New York, 1988.

Rubin, James H. *Courbet* (Art and Ideas), London, 1997.

Rubin, James H. *Impressionism* (Art and Ideas), London, 1999.

Seibert, Margaret A. "A Political and a Pictorial Tradition Used in Gustave Courbet's *Real Allegory*," *Art Bulletin*, LXV/2, 1983, pp. 311–16.

Thomson, Richard. "'Les Quat' Pattes': The Image of the Dog in Late Nineteenth-Century French Art," *Art History*, V/3, 1982, pp. 323–37.

Toussenel, Alphonse. *L'Esprit des bêtes: Zoologie passionnelle*, Paris, 1855.

Varnedoe, Kirk. *Gustave Caillebotte*, New Haven and London, 1987.

PHOTOGRAPH CREDITS

INDEX

Note: Page references in *italics* indicate illustrations.

Index compiled by Meg Davies (Registered Indexer, Society of Indexers)